August Sander

Seeing, Observing and Thinking

August Sander
Seeing, Observing and Thinking
Photographs

With texts by August Sander
and Gabriele Conrath-Scholl

Die Photographische Sammlung/SK Stiftung Kultur
Fondation Henri Cartier-Bresson
Schirmer/Mosel

This book is published on the occasion of the exhibition
August Sander – Seeing, Observing and Thinking
from September 8 until December 20, 2009
at Fondation Henri Cartier-Bresson, Paris.

Contents

I'm often asked how I got my ideas for this work: *Seeing, Observing and Thinking* and the question is answered.

August Sander, "My Confession of Faith in Photography", November 1927

August Sander at the Fondation Henri Cartier-Bresson

Although the approaches they adopted were very different, August Sander (1876–1964) and Henri Cartier-Bresson (1908–2004) shared a curiosity for the world which found expression in the relentless observation of reality.

After all, what could be more alien to Cartier-Bresson than the idea of series, a concept which was central to Sander's work?

HCB was a sophisticated citizen of the world, shaped by a vast culture and very much linked to the intellectual movements of the Thirties. He fed this curiosity by traveling endlessly for picture stories, while his insatiable appetite for literature and painting combined with his legendary impertinence were also key ingredients. The world is his studio, motion is his rhythm and the moment is a flash of lightning.

August Sander traveled little but was seduced by photography at a very young age and established his own studio in Cologne in 1910. In the early 1920s, he is very close to German artistic movements of the day and is connected to several painters and musicians while maintaining his studio with numerous commissioned portraits. He develops his vast documentary project "People of the Twentieth Century" around 1925 and this is basically an attempt to sketch the society of the time. Very soon, the importance of the environment emerges; it's worth mentioning that his photographic epiphany came one day when he was still a teenager as he looked at a cloudy sky through a lens. The challenge he set himself was to show the unity between men and the natural spaces they shape, even showing the unity which exists between a flower or a mushroom and their surroundings.

TIME

Initial drafts of his project *Antlitz der Zeit,* published in 1929, present a selection of portraits organized in social categories, the entirety of which had to be "framed", so to speak, in order to create the portrait of an age; at the same time, he begins compiling portfolios of typical

landscapes. We are delighted to have the opportunity to present one of these: "The Rhine and the Siebengebirge" at the Foundation. This vision of Sander's was at once typological (for the portraits) and topographical (when speaking of landscapes), he also uses the expression *physiognomy* for both groups and was diametrically opposite to the idea of immediate capture pursued by Cartier-Bresson and his so-called *candid camera* (which was never really "candid" by the way).

Sander never wanted to use the Leica which HCB used as an extension of his own eyes, ensuring his spontaneity. Ironically, the Leica had been invented in Germany at the time. Sander always preferred the large-format camera with long exposure times, all the better for focusing on details and a person's posture – immobility in other words.

<div align="center">SERIES</div>

Later on when HCB furtively attempts to capture the "inner silence of a willing victim"*, Sander seeks the active participation of the model, even going so far as to claim he was merely "assisting a self-portrait". His genius lies in his ability to organize this inventory and manage the multiplicity of images while feigning self-effacement though it is very doubtful that this attitude was genuine. HCB seeks to capture what is "true" in the absence of pose whereas Sander tries to portray an entire age in Germany (people and landscapes) while being systematic in the methods he uses and eschewing sentimentality and lyricism as a matter of principle.

Indeed, it is in terms of closely linked series that he regards his work, lending prestige to the documentary style which the American photographer Walker Evans would develop in a different direction, followed by several photographs influenced by what is referred to as the "Düsseldorf School".

Attempting to present Sander's work by placing portraits, landscapes and botanical studies side by side is to do justice to the innate spirit of the methods he deployed. Always striving to show to what extent all things are linked, Sander seeks to materialize these very links themselves with his close-ups of the human skin (plate 105), his intricate network of grass (plate 97) or his portrait of painter Anton Räderscheidt (plate 65) in a deserted street (echoing Räderscheidt's depiction of himself in his paintings).

We owe a great debt to Die Photographische Sammlung/SK Stiftung Kultur in Cologne who graciously accommodated our wish to show the close interlinkage between portraits and landscapes in Sander's work. This exhibition of about one hundred of his original exposures

* Henri Cartier-Bresson, *An Inner Silence. The Portraits,* Thames & Hudson, London 2006.

is enriched by the publication for the first time in French of the text of Sander's 1931 radio lecture entitled "Photography as a Universal Language" where he lucidly develops his desire to comprehend humanity in the manner of a scientific observer. This preoccupation was also shared by numerous intellectuals from the turbulent period of the Weimar Republic.

Whatever his taste for precision or his obsessions with sociology and anthropology, it is by means of this "pure observation" as described by Walter Benjamin that Sander attains excellence in his approach, one which is characterized, so to speak, by effacement. Moreover, by virtue of his talent for observation and his pronounced interest in the spiritual, he never completely turns his back on cloudy skies. After all, was it not his great dream to create a vast photographic cartography of the sky and the stars?

AGNÈS SIRE
Director
Fondation Henri Cartier-Bresson

Perspectives—Notes on the Work of August Sander

GABRIELE CONRATH-SCHOLL

"Seeing, Observing and Thinking": This motto describes August Sander's empirically based approach to developing his œuvre over half a century, methodically refining it from the mid-1920s onwards with his growing archive in mind.[1] With this formula, he made his position clear as someone who not only participated in events but also maintained a contemplative distance. The formula should also be understood broadly as a recommendation for viewing things— above all, for viewing his pictures. Upon closer inspection, one finds a kind of progressively ongoing cycle of cognition nourished from many sources and stemming particularly from the life stories in question. What follows, then, is a review of the important stations in Sander's life and an overview of his œuvre, his aims, and his career.

CHILDHOOD AND YOUTH — EARLY CAREER — HIS APPROACH TO PHOTOGRAPHY

For Sander's life, four places were significant: Herdorf in the Siegerland, Linz in Austria, Cologne in the Rhineland, and Kuchhausen in the Westerwald. Born in 1876 in Herdorf as the second son of a carpenter working in a mine, Sander grew up in a family with seven children and visited the local school until he was fourteen. Like many boys from Herdorf, he worked on a local mining waste tip; he practiced taking photographs in his free time until he was called for military duty in Trier in 1897. Back then, the region around Herdorf was rich in iron ore deposits and temporarily became one of the most significant industrial locations in the Siegerland. Up to the twentieth century, the region and its people profited from a relatively stable economic structure in which wage dependency and destitution hardly played a role.[2] "It is a peculiarity of the Siegerland," says local historian Josef Hoffmann, "that industry and nature are situated so closely together, perhaps unlike any other place in Germany."[3] Late into his senior years, August Sander was still mentioning the influence of such early impressions, which awakened his attentiveness to his environment and to the diversity of humanity.[4]

In 1901, the young photographer traveled to Linz, in Upper Austria. After years of schooling and traveling, during which he also exposed himself to painting, Sander started working at the Photographische Kunstanstalt Greif, a photography studio, which he and a business associate took over in 1902. From 1904 to 1909, he ran the studio himself. The time in Linz was not only signicant for Sander's first professional successes; it was also then that he started a family with Anna Sander, née Seitenmacher, whom he married in 1902. His sons Erich (1903-1944) and Gunther (1907-1987) were born and grew up in the father's business. As was later the case in Cologne, living spaces and work areas were not separated. Gradually, a business developed that to some extent drew in all members of the family; assistants were also present and, in the Cologne days, the studio was even recognized as a training ground for apprentices.

In provincial Linz, with about 60,000 residents, there was an active cultural life, and Sander contributed to it with his atelier and commissions, such as the one for the local art and cultural history museum, Francisco Carolinum. Beyond that, he was a member of the Upper Austrian Arts Association, occasionally exhibited a few of his paintings and pastels in group exhibitions[5], participated in lute performances and charitable activities, visited song recitals, and fostered contacts with a variety of painters teaching at public and private schools and with actors at the Linz Regional Theater.[6] According to the 1909 annual report for Linz's choral group *Frohsinn* [Merriment], Sander was joined there by public servants, teachers, professors, merchants, doctors, technicians, insurance representatives, a few lawyers, notaries, journalists, as well as some who were independently wealthy.[7] As we can see from the photos still extant, he recruited his clientele from all of these backgrounds.

In 1906, on his thirtieth birthday, August Sander presented 100 photographic works in a comprehensive exhibition at the Linz Country House Pavilion. According to the catalogue, portraits of men and women, landscapes and genre photographs, portraits of groups and pairs, and pictures of children were among the works displayed, all using a variety of techniques.[8] Apparently, Sander already had a decidedly artistic sense of himself and had developed his range of motifs: He was praised for "the accurate apprehension of the person's characteristics"[9]; he was also lauded for refraining from prettifying his subjects with touch-ups and for photographing his subjects in their domestic surroundings (as well as in the studio). The landscapes on display, insofar as they're still identifiable today, were highly varied in content as well as form. Wild landscapes were shown alongside cityscapes of historical buildings, churches and castles—and a technical feat, the Elberfeld elevated railway that started operating in 1901. This choice of subject shows that a few works originated on trips to Germany. In general, the time in Linz was characterized by a wide range of subjects and photographic techniques. Object studies, landscapes and city views are found alongside portraits.

In his early career, August Sander participated in a variety of international exhibitions and competitions, receiving numerous awards.[10] Above all, however, his activities won him a look into the controversial discussion that was taking place about a renewal of photographic praxis, which was then still hovering between pictorialism and documentary approaches. These would all be experiences he would draw upon in later years.

August Sander returned to Germany in 1910, moving to urban Cologne, which signified another change in dimensions for him. After initial difficulties, the family eventually found a suitable atelier combined with an apartment at Dürener Straße 201 in the Lindenthal section of the city. The apartment would become their permanent residence. In 1911, a daughter, Sigrid, was born; her developmentally damaged twin brother, Helmut, died soon after birth. August Sander commemorated the dramatic event with the impressive picture, *Meine Frau in Freud und Leid* [My Wife in Joy and Sorrow]. The studio in Lindenthal remained the center of family life until 1942/43. As the air raids of World War II increased in intensity, August and Anna Sander moved to the tiny village of Kuchhausen in Westerwald. There, Sander labored under very adverse conditions to complete his work—until 1964, when, at the age of 87, he died in a Cologne hospital, seven years after his wife.[11]

Contrary to the opinion propagated in various writings, August Sander also participated actively in events after the war. He maintained his contacts in Cologne and, drawn by the cultural milieu of the city, attempted to return—to no avail. He and his wife then turned—with abundant technical skill, persistence and creativity—to making their new home in a village of just a handful of houses, settling into a few rented rooms in a simple farmhouse built in the seventeenth century. They planted a garden by the house, surrounded by a sweeping landscape that in the distance stretched into the characteristic panorama of the Siebengebirge.

The 1920s and 30s were undoubtedly the most eventful period of Sander's career, starting in the years before World War I, when he fostered a clientele in Cologne as well as his home in Westerwald, 100 kilometers away—a feat involving multi-day sojourns, train trips, and bicycle tours. Countless photographs, many of them important, were produced in this time. Familial celebrations such as birthdays, confirmations, weddings, or anniversaries offered multiple occasions for contract work that Sander delivered to his customers—framed and unframed, in the form of enlargements or as contact sheets from glass plate negatives, mounted on card stock. If the customer didn't come to the atelier, Sander seized the initiative. Loaded with equipment—tripod, large-format camera and negative plates—he proceeded to the appointed place and acquainted himself with the people or whatever it was he needed to photograph. Choosing a vantage point and the motif for the background was of huge importance—especially in terms of lighting. Later, the people were to appear in the picture in a manner both natural and suited to the special situation; the surroundings—if not being

rendered utterly neutral—were to reflect an aspect of real life, without slipping into clichés or anything resembling genre photography.

With few exceptions over the decades, Sander maintained this approach of weighing as many components of the pictorial composition as possible and finally applied it to his landscapes, architectural pictures and botanical studies as well. He was only open to chance if it benefited the naturalness of an adopted pose or a found arrangement. The artistic balancing act that was always negotiated so successfully by Sander was to be found precisely in the conflation of all these photographic criteria. We see this in works such as *Bauer* ["Farmer," 1910], *Mutter und Tochter. Bauern- und Bergmannsfrau* ["Mother and Daughter: Wife of a Farmer, Wife of a Miner," 1912], *Der Herr Lehrer* ["The Teacher," 1910], *Kleinwüchsige* ["Midgets," 1906–1914], and the famous photograph of the *Jungbauern* ["The Young Farmers," 1914], which, according to one of the persons depicted, was taken by Sander while the group was taking its Sunday walk to the dance hall. Sander captured them in his admirably unerring and rhythmic way.[12] Knowing their historical significance after World War I, August Sander returned to the negatives of these photographs and enlarged them as prints for his portfolio, which he was constantly working on.

SANDER'S CONCEPT – INFLUENCES AND SUCCESSES – POLITICAL REPRESSIONS

In a letter dated 1925 to collector and photography expert Erich Stenger, August Sander describes his overarching goal: "In order to summon a cross-section of our time and of the German people, I've collected these photographs in portfolios and, in doing so, I'm starting with the farmers and ending with representatives of the cultural aristocracy. This process is being framed in the aforementioned portfolio being developed in tandem, which depicts the development from village to the most modern metropolis. – Using absolute photography to frame the individual classes as well as their surroundings, I hope to provide a true psychology of our time and of our people."[13]

The work, totaling between 500 and 600 photographs, was called *Menschen des 20. Jahrhunderts* [People of the Twentieth Century]. It comprised 45 portfolios divided into the following seven sections: *The Farmer, The Skilled Tradesman, The Woman, Classes and Professions, The Artists, The City* and *The Last People*. With a selection of about 100 portraits from a variety of vocational and social groups, Sander showed his project in the Kölnischer Kunstverein [Cologne Art Association] in 1927 for the first time.[14] A review of the exhibit written two years later indicates the extent to which even this selection hinted at the dimensions the future portrait œuvre would take: "The whole, broad front—from the farmer to the literary critic, from

the industrialist to the unemployed—is captured here, usually each in multiple instances, and the result is that the structural transformation [of society] is rendered immediately comprehensible."[15]

While it is true that the desired total of photographs had not yet been reached by 1927, the basic concept was there, and its continuation required Sander to consider and reconsider his career as a photographer.[16] Sander elucidates this in the brochure accompanying his exhibition and for the first time formulates his guiding principle: "I'm often asked how I came upon the idea of creating this work: Seeing, Observing and Thinking and the question is answered. Nothing seemed more appropriate to me than to render through photography a picture of our times which is absolutely true to nature. […] The exhibition at the Kölnischer Kunstverein is the result of my quest and I hope I am on the right path. I hate nothing more than sugary photographs with tricks, poses and effects." [17]

The surviving reviews show that his intentions were already understood in the 1920s. The *Rheinische Tageszeitung*, for example: "One sees working class families, generations, farmers' heads […] the modern woman in all her varied forms […]; the city youth. Cologne's cognoscenti, poets, musicians, scholars, and finally pictures of the street, characters from the big city: beggars, court musicians and gatherings of people. By looking at all of these people captured individually, a sense of the totality accrues, of the human types of the twentieth century and the face of our time."[18]

The motifs mentioned here could be referring directly to the photographs in our catalogue. Consider, in addition to the aforementioned pictures: *Herrenbauer* ["Gentleman Farmer," 1924], *Dorfpfarrer mit Familie* ["Village Pastor with Family," 1920–1925], *Frau eines Architekten (Dora Lüttgen)* ["Wife of an Architect," 1926], *Reichspräsident Paul Hindenburg und Oberbürgermeister Konrad Adenauer* [1926], *Boheme (Willi Bongard und Gottfried Brockmann)* [1922–1925], or *Berginvalide* ["Disabled Miner," 1927/28]. Particularly worth highlighting is the photograph *Maler (Anton Räderscheidt)* ["Painter," 1926]. It shows its subject in the style of his own artworks, on Cologne's Bismarckstraße in the early hours of morning.[19] The masculine figure in a dark coat and bowler hat stands out as a silhouette against the light morning gray of the urban backdrop, creating a surreal, floating effect reminiscent of René Magritte. Here, Sander demonstrates that the documentary effect of the photograph can unquestionably go hand in hand with a situational "mise-en-scène" without distorting reality. Räderscheidt belonged to the "Cologne Progressives" artist group dominated by Franz Wilhelm Seiwert and Heinrich Hoerle. Politically engaged and open to all forms of artistic expression—be it painting, sculpture, graphic arts, literature or photography—the group formed an informal collective in which the most varied stylistic directions were practiced: Expressionism, Objectivity, Cubism, Constructivism. And yet it was bound by a common interest in capturing the

individual and his social structure in typified portrayals. These artists valued Sander's objective style—his photographs' mirroring of reality—as an autonomous, artistic creation, and they supported the photographer in his aims and actions in a variety of ways.[20] Seiwert, for example, wrote numerous letters of introduction that put August Sander in contact with people in Berlin—with poet Erich Mühsam, for example, photographed in front of his house along with his friends Alois Lindner and Guido Kopp for the 1929 picture, *Revolutionäre*.[21] About five years later, Mühsam was murdered by the National Socialists in the Oranienburg concentration camp.

Within his own family, August Sander would experience how the political conditions of the 1930s could reach into the private sphere. As a result of political involvement with the Socialist Workers' Party of Germany, banned in 1933, his son Erich, who had studied Economic and Social Science in Cologne, was arrested by the National Socialists in 1934 and sentenced to ten years in prison. Most of his term of imprisonment was spent in the Siegburg penitentiary, where, in 1944, he died as a result of insufficient medical care shortly before his scheduled release. Familial and spiritual intimacy find moving personal expression in the surviving letters to his parents.[22]

One can see Erich in Sander's group portrait, *Werkstudenten* [1926], on the side to the left. As in the aforementioned group portrait, *Revolutionäre*, in retrospect it refers once more to the era's idealistic conceptions of the world, which would soon be so violently destroyed. In 1946, August Sander wrote to Hans Schoemann, found next to Erich Sander in the photo: "Erich always showed great interest in my work. When a member of his circle asked him what he would do after the war, he said, 'I'll continue the work of my father.' Hardly a letter of his came from Siegburg that didn't contain inspiration for something."[23]

Erich Sander's letters repeatedly include requests for books that suggest his interests.[24] A few publications from his time at university were in his father's library[25], and they comprise a broad spectrum of literature from the humanities and sciences: Darwin, Freud, Ernst Haeckel, Hegel and—again and again—Goethe, whom August Sander held in particularly high esteem. These, along with numerous textbooks on photography, must have provided important stimulation in 1931 as he was preparing his lecture series for the Westdeutscher Rundfunk, *Zum Wesen und Werden der Photographie* [The Essence and Development of Photography].[26] One of these lectures, "Photography as a Universal Language," is presented as an example in the present volume. In spite of some imprecision and errors in judgment, there is clearly sophistication in Sander's efforts at understanding the pictorial language of photographs as a medium of communication while striving to make his own viewpoint clear.[27] In 1930, he had traveled to Vienna to see his friend Gerd Arntz, who was also artistically active and worked as the head of the graphics department at Vienna's Museum for Society and Eco-

nomics, which was led by Otto Neurath, whose pedagogical views he shared. In search of a universal visual language, Neurath and Arntz later developed the so-called "Isotype" (International System of Typographic Picture Education), easily comprehensible pictograms to optimize understanding.[28] One can assume that Sander's visit to Vienna influenced the direction of his lecture, especially because he was also searching—with his view on types—for grand patterns and rules that would be immediately communicatory.

No later than the exhibition at the Kölnischer Kunstverein in 1927, Sander proved that, as a professional photographer, he was not only capable of taking individual portraits but also of culling images that represented a vocational or societal type, a certain climate, an attitude towards life or a Zeitgeist. His intention was to create a complex *Kulturwerk* ("culture work"), a kind of long-term developmental scientific study, whose exemplary nature took as its starting point the presentation of successful individual portraits. In so doing, he gave the history of photography an important impulse that inspired many artists and photographers in subsequent generations. In this regard, his book, *Antlitz der Zeit. Sechzig Aufnahmen deutscher Menschen des 20. Jahrhunderts* [Face of Our Time: 60 Photographs of German People in the Twentieth Century], published in 1929 as a preview of his planned portfolio, *People of the Twentieth Century*, was a prodigious success and was even recognized as such across the Atlantic. In 1931, American photographer Walker Evans expressed his admiration for the book.[29] In his introduction to *Face of Our Time*, Alfred Döblin writes:

"To write sociology without writing; instead, proffering pictures, pictures of faces rather than traditional costumes: That is what is accomplished by the gaze of this photographer—by his intellect, his power of observation, his knowledge and, last but not least, his tremendous photographic skill. As with comparative anatomy, the study of which brings us to an understanding of nature and the history of organs, this photographer has created a comparative photography and thereby achieved a scientific viewpoint beyond the photographers of detail. We are free to take any number of things from these pictures; together, the pictures are admirable material for the cultural, economic and class history of the last thirty years."[30]

In the era of National Socialism, Sander's *Face of Our Time* was criticized because its images did not convey the reigning ideal. Sander's pictures of individuals, impartially represented and lined up next to one another in a spirit of equality, couldn't help but meet with rejection in the committees of the governing party. The printing blocks of the book were destroyed, and it was no longer permissible to ship it after 1936.[31]

If his achievements are primarily identified today with his portraits, it is because the *People of the Twentieth Century* project was for Sander himself of the utmost importance, as various personal documents show. The extent to which this made him a citizen of the world is pointed out by Manuel Gasser, editor of the Swiss magazine *du*, which dedicated a special issue to August Sander in November 1959:

"For Sander, it was all about portraying the individual as a creature of society, and if it was the case that he stuck with his people, the Germans, it was simply because he didn't have access to others. If he had been born 100 kilometers to the west, beyond the French border instead of in Westerwald, he would have photographed people who were just as specifically French, and they would certainly not have come off any better. Because there are Sander types, Sander characters, everywhere. Even here."[32]

Today, as always, Sander's reception is focused on his portrait work. The picture series selected for this catalogue, which also includes landscape and nature photography, nevertheless demonstrates just how important the interaction of various subjects is for understanding his fundamental motivation: to use photographic images to create a basis for the free exploration of the conditions of life. This book opens—emblematically—with a romantic portrait of Sander showing him as a gazer looking out in the distance, in tune with nature and earth. The individual and the world in which he lives belonged together in the totality of Sander's thought, and he dedicated himself to both with equal measures of empathy and scientific. In his photos of natural and cultivated landscapes, the biological, geological or meteorological phenomena interested him just as much as signs of human encroachment, regardless of whether their origins were recent or went back a thousand years.[33] Thus an autobahn is as entitled to its place in a picture as a quarry or mountain formation. In his 1975 article on Sander's *Rheinlandschaften*, Wolfgang Kemp writes, "Sander includes the traces of human activity in the context of a landscape. Houses, factories, ships, streets, paths, train tracks are present; rising smoke and vestiges of mining in the rocks attest to human confrontation with nature. And there are landscapes [...] that are empty, but empty like a factory yard after closing time."[34] Unprettified landscape photography, for which August Sander can serve as a pioneer, became widespread in the 1970s, particularly in the USA. One need only think of the *New Topographics* movement[35], or of Bernd and Hilla Becher.

Sander's series *Der Rhein und das Siebengebirge*, photographed in the late 1920s and early 30s and assembled in 1935, is a good example of the various aspects of his landscape photography. He also dedicated several series to the region of the Siebengebirge located near Cologne. In *Die Flora eines rheinischen Berges* [The Flora of a Rhenish Mountain], he shot

botanical studies—including ones of orchids whose location he gleaned based on a tip from Erich Sander.[36] He often photographed the characteristic traits of the Siebengebirge from an elevated vantage point on Wolkenburg Mountain, near an old larch tree. The distant view enabled him to follow the route of the Rhine, to capture the changing light and cloud formations, and to observe the atmosphere and vegetation in all their seasonal variations. Fields and settlements are visible, sometimes even recognizable in detail; castles and ruins like the Drachenfels point to the history and mythology of the Nibelungen. The photographer tried to grasp the area by means of a kind of overarching cartography of impressions.

For August Sander, landscape was not—as often misrepresented in critical literature—a theme he retreated to in the era of National Socialism.[37] It was always a part of the total concept, and he often used nonlocal portrait commissions as an opportunity to photograph the surrounding landscape. Publishers specializing in tourism and local history were interested in Sander's works; the result included landscape brochures such as *Die Eifel, Bergisches Land, Am Niederrhein, Die Mosel, Das Siebengebirge* and *Die Saar,* all done between 1933 and 1935.[38]

In the current presentation, the two grand themes of the individual and landscape are accompanied by photographs that could be described as detail studies. As mentioned earlier, these consist of close-ups of parts of nature, or parts of plants; they also include hand studies. They are considered part of Sander's project *Studien, der Mensch* [Studies, the Individual], which he had pursued in various ways and phases since the 1920s. Apart from pictures of hands in various positions taken specifically for this series, he also used negatives from his archive, enlarging the appropriate areas. A project list from the 1950s indicates that Sander envisioned two volumes as textbooks for this subject. His note reads: "'Studies, the Individual,' the organic and inorganic tools of humans. (For elementary and secondary schools.) The second volume is in progress."[39] If Walter Benjamin already saw *People of the Twentieth Century* as an "atlas of instruction" (*Übungsatlas*)[40]—admittedly in sociological terms—here, Sander's fondness for collections of patterns and models with didactically lexical characteristics finds its confirmation—as one also finds with Hermann Krone, Fritz Matthies-Masuren, or Ernst Haeckel, Moritz Meurer and Karl Blossfeldt.

Against the background of a similarly objectifying approach, the names of Blossfeldt and Sander are often mentioned in the same breath. And yet there are individual differences amidst the comparable motifs. For Karl Blossfeldt, purely formal considerations stand in the foreground; Sander, however, is interested in the shape of plants as well as their "biotope". The inclusion of their immediate living conditions—the light, the quality of the soil and the surrounding plant populations—hold decisive significance for him. An especially impressive expression of this can be found in the photograph, *Die Wolkenburg, Lianen und Tannen, Frühlingsanfang* [The Wolkenburg, Lianas and Fir Trees, Early Spring]. Sander

apparently approached the photography of plants with the same analytic rigor that distinguishes his portraits. In both cases, the individual and the typical find their background in their environments.

Precisely because of his analytical rigor, Sander also concerned himself with the surface of things—as evidenced by his close-ups of human skin or tree bark. The photographs *Epidermis*, from 1925, and *Birke* [Birch Tree], from the 1930s, make this clear in exemplary fashion. A passage from Goethe's *Schriften zur Allgemeinen Morphologie* [Notes on General Morphology]—this book is also in Sander's library—appears to have inspired the photos in question: "Tree barks, insect skins, animal hairs and feathers, even human skin: They are all eternally isolating covers; they repel; they have given themselves up to a status of Non-Life. Behind them, new covers are constantly forming, and under them, closer to the surface or deeper, life produces its creative tissue."[41] The photograph *Epidermis* concludes the sequence of photos in this catalogue. With Goethe's words in mind, new ways of seeing the photographer's work can arise, especially when one realizes that the skin depicted belongs to August Sander himself: The glass plate negative from which this image has been cropped shows the photographer's cheek.[42] We're dealing with a self-portrait, so to speak, reduced to matter that has no choice but to submit to organic and ultimately spiritual changes.

August Sander strove to document the epoch in which he so profoundly participated, and he aimed to do so with faithfulness to detail and impartiality—for himself and for posterity. In choosing a medium, he opted for the possibility of exact reproduction offered by photography and in doing so alluded to what he saw as the originary qualities of the medium.[43] His images and picture series enrich our imagination thanks to the sober and concentrated observation underlying them, and yet they are also cause for deeper contemplation. The apparently posed content and the entire potential—contradictory, emotional and latent—of the reality registered by him: All of it receives an individual and vivid face. August Sander has succeeded in creating a work at once documentary and visionary, a work that—beyond its subject matter—exemplifies a period of time that contained much cause for conflict. He shows us a world in transformation that is fragile, yet enduring. August Sander allows us to—in the best sense of the word—look twice: at the world and at its image.

[1] Gerd Sander highlighted this maxim in 1994 in his memories of his grandfather and sees it as a kind of dowry supporting him in his engagement with the photographer's legacy. Cf. Gerd Sander: "Thoughts on my Grandfather," in *August Sander: "In der Photographie gibt es keine ungeklärten Schatten!"* [In Photography, There Are no Unexplained Shadows!], published on the occasion of an exhibition bearing the same title, curated by Gerd Sander. Exhibition toured to: Pushkin State Museum of Fine Arts, Moscow; Watari-um, Museum of Contemporary Art, Tokyo; Kunstmuseum Bonn; Centre National de la Photographie, Paris; Palais des Beaux-Arts, Brussels; Stedelijk Museum, Amsterdam; Museo di Storia della Fotografia Fratelli Alinari, Florence; National Portrait Gallery, London. Foreword by Susanne Lange, texts by Gerd Sander, Christoph Schreier. Berlin: Ars Nicolai, 1994, German ed., p. 9.

[2] Cf. Otto Kipping: *Herdorf. Geschichte des Grenzraumes Siegerland-Westerwald* [Herdorf: History of the Siegerland-Westerwald Border Area]. Kirchen: Publ. Walter Hebel, 1978. Paul Fickeler: *Das Siegerland als Beispiel wirtschaftsgeschichtlicher und wirtschaftsgeographischer Harmonie* [Siegerland as an Example of Historical and Geographic Harmony in Economics]. Bonn: Ferd. Dümmlers Verlag, 1954.

[3] Josef Hoffmann: *Der ewige Bergmann* [The Eternal Miner]. Vol. 1, Rheinhausen: Deutscher Wald Verlag, 1958, p. 248.

[4] Cf. Jutta Duhm-Heitzmann: "Todestag des Fotografen August Sander, 20.4.1964" [The Anniversary of the Death of Photographer August Sander, 20.April 1964] in: *Zeitzeichen*, broadcast series by WDR broadcasting, Cologne, 20 April 1989. August Sander: "Wildgemüse und was sie wirken. Plauderei mit eigenen Farbaufnahmen von August Sander" [Wild Vegetables and their Effects. August Sander Chats about his own Color Photos], in: *Velhagen & Klasings Monatshefte*, Berlin: Velhagen & Klasing, June 1937, pp. 361–364.

[5] Martin Hochleitner: "August Sander und die Linzer Jahre" [August Sander and the Linz Years], in: *August Sander. Linzer Jahre, 1901–1909*, Ed. Die Photographische Sammlung/SK Kultur Stiftung, Cologne, and the Landesgalerie Linz am Oberösterreichischen Landesmuseum. Munich: Schirmer/Mosel, 2005, p. 58.

[6] Cf. ibid., p. 60 ff.

[7] Cf. ibid., p. 62.

[8] Gabriele Conrath-Scholl: "August Sander – Grundlage, Ambitionen und erste Erfolge" [August Sander—Background, Goals and First Successes], in: *August Sander. Linzer Jahre, 1901–1909*, 2005, p. 20.

[9] *Linzer Tagespost*, 1906, cited by August Sander: "Werbeschreiben, 1912." Document, REWE Library in Die Photographische Sammlung/SK Stiftung Kultur, August Sander Archive, Cologne.

[10] Cf. Gabriele Conrath-Scholl: "August Sander – Grundlage, Ambitionen und erste Erfolge" in *August Sander. Linzer Jahre, 1901–1909*, 2005, pp. 12–14.

[11] August Sander transported the most valuable archival assets to Kuchhausen in 1942/43. What he had left behind in his cellar in Cologne for shipment at a later time was burned in January 1946. This included 25,000 to 30,000 negatives. When Die Photographische Sammlung/SK Stiftung Kultur acquired the August Sander Archive in 1992, it included approximately 3,500 original prints, which has since been expanded thanks to purchases, gifts and extended loans by an additional 1,000 works, 10,700 original negatives, correspondence, sections of the photographer's library, equipment and furnishings. The purchases were funded in part by REWE, Cologne, and the Kulturstiftung der Länder, Berlin.

[12] Ulrike Mast: "'Ewald du hängst in Köln om Hauptbahnhof', 'Modell' des August Sander sechzig Jahre später" ["Ewald, You're Hanging in Cologne's Train Station": An August Sander 'Model', 60 Years Later], in *Rheinzeitung*, Westerwald/Sieg, No. 232, 13 Oct. 1976.

[13] August Sander to Erich Stenger, 21 July 1925, document in Ludwig Museum, Cologne, Agfa Collection.

[14] This was a community exhibition in which August Sander was apparently given a particularly large amount of space. Other participants included Peter Abelen, Franz Esser, Peter Hecker, Heinrich Hoerle, Anton Räderscheidt and Franz Wilhelm Seiwert. Cf. Josef Ludwig: "Bildende Kunst in Köln, 1. Kölnischer Kunstverein" [Fine Arts in Cologne, The First Cologne Art Association], in *Rheinische Zeitung*, Cologne, No. 284, 1927.

[15] Georg Risse, "Gesichter unserer Zeit" [Faces of Our Time] in *Rhein-Mainische Volkszeitung*, 5 April 1930.

[16] Cf. Susanne Lange, Gabriele Conrath-Scholl: "Menschen des 20. Jahrhunderts. Ein Konzept in seiner Entwicklung" [People of the 20th Century: Development of a Concept], in *August Sander. Menschen des 20. Jahrhunderts, Studienband*, Ed. Die Photographische Sammlung/SK Stiftung Kultur, Cologne, a publication accompanying the seven volume reissue of August Sander's *Menschen des 20. Jahrhunderts*, Munich: Schirmer/Mosel, 2001, pp. 12–43.

17 August Sander, "Mein Bekenntnis zur Photographie, November 1927" [Confession of Faith in Photography], Document, REWE Library in Die Photographische Sammlung/SK Stiftung Kultur, August Sander Archive, Cologne.

18 "Menschen des 20. Jahrhunderts. Eine Lichtbildausstellung in Köln" in *Rheinische Tageszeitung*, No. 329, 29 Nov. 1927.

19 Cf. Anne Ganteführer-Trier: "Zeitgenossen" [Contemporaries] in *Zeitgenossen. August Sander und die Kunstszene der 20er Jahre im Rheinland*. Texts by Birgit Bernard, Gertrude Cepl-Kaufmann, Anne Ganteführer-Trier et al., Göttingen: Steidl Verlag, 2000, p. 26.

20 Franz Wilhelm Seiwert expressed his approval in 1930 in the newspaper he founded with Heinrich Hoerle, *a bis z, organ der gruppe progressiver künstler* [a to z: voice of the group of progressive artists]: "it [sic] is the precursor of the great contemporary history in photographs, the collection and ordering of which has been worked on by Sander for decades. their gradual publication indicates the goal set by Sander for himself and photography[;] it gives photography a meaning which, so to speak, lay in the street and—because of this—wasn't picked up until now. photography is taking away painting's job of creating images of the essance of time that will serve as documents of our time, passed down from our era to future ones. it thus assigns painting another task as representative art—serving as a utopian world view in our time." Franz Wilhelm Seiwert. "august sander: antlitz der zeit", in *a bis z, organ der gruppe progressiver künstler*, 3/1930, p. 22.

21 Cf. Franz Wilhelm Seiwert to Oskar Kanehl, Ludwig Thormaehlen, Hans Richter, James Broh, Hermann von Wedderkop, five letters dated 15 Mar. 1928; August Sander to Charlotte Mühsam, 8 Dec. 1959. documents, REWE Library in Die Photographische Sammlung/SK Stiftung Kultur, August Sander Archive, Cologne.

22 Cf. Susanne Lange, Gabriele Conrath-Scholl: "Menschen des 20. Jahrhunderts. Ein Konzept in seiner Entwicklung" in *August Sander. Menschen des 20. Jahrhunderts, Studienband*, 2001, pp. 34-35.

23 August Sander to Hans Schoemann, 26 July 1946, document, REWE Library Die Photographische Sammlung/SK Stiftung Kultur, August Sander Archive, Cologne.

24 Thus Erich Sander lists, e.g.: "Mommsen: Empire of Caesars; Hegel: Logic Vol. 2; Fichte: Macchiavelli; Macomlay: Macchiavelli; Essay Concerning Human Understanding; Tarrasch: Book on Chess; Balzac: 2 Vol." Erich Sander to August and Anna Sander, 4 Jan. 1935, document, REWE Library in Die Photographische Sammlung/SK Stiftung Kultur, August Sander Archive, Cologne.

25 Occasionally, books are provided with Erich Sander's name. Cf. REWE Library in Die Photographische Sammlung/SK Stiftung Kultur, August Sander Archive, Cologne.

26 Gunther Sander, "Aus dem Leben eines Photographen" [From the Life of a Photographer], in *August Sander. Menschen ohne Maske, Photographien 1906–1952* [AS: People without Masks, Photographs], Munich: Schirmer/Mosel, 1976 (Special edition, 1971, in *August Sander, Menschen ohne Maske*, C.J. Bucher-Verlag), p. 22.

27 Cf. in the present catalogue, "August Sander. Photography as a Universal Language," p. 25–31

28 Cf. Gerd Arntz, "Erinnern durch Abbilden. Eine autobiographische Skizze" [Rememberence via Image. An Autobiographical Sketch] in *Gerd Arntz. Zeit unterm Messer, Holz- & Linolschnitte 1920–1970*, Cologne: informationspresse-c.w.leske verlag, 1988, pp. 13–44, esp. pp. 23–28. Cf. further to Otto Neurath www.vknn.at/neurath/ [from June 2009].

29 Cf. Walker Evans, "The Reappearance of Photography" in *Hound and Horn*, Vol. 5, No. 1, Oct.-Dec. 1931, pp. 125-128.

30 Alfred Döblin, "Von Gesichtern, Bildern und ihrer Wahrheit" [On Faces, Pictures, and their Truth], in *August Sander. Antlitz der Zeit. Sechzig Aufnahmen deutscher Menschen des 20. Jahrhunderts* [August Sander. Face of Our Time. 60 Photographs of Germans from the Twentieth Century]. Munich: Schirmer/Mosel, 2003. (First ed.: Munich: Kurt Wolff/Transmare, 1929.) p. 14.

31 Cf. Susanne Lange, Gabriele Conrath-Scholl, "Menschen des 20. Jahrhunderts. Ein Konzept in seiner Entwicklung" [People of the Twentieth Century. Development of a Concept] in *August Sander. Menschen des 20. Jahrhunderts, Studienband*. 2001. p. 18, note 45.

32 Manuel Gasser, "Auskunft über den Photographen August Sander" *in August Sander photographiert: Deutsche Menschen. du* (cultural monthly), Vol. 19, 11/1959, p. 67.

33 Cf. August Sander, "Photography as a Universal Language": "Thus having depicted the physiognomy of individuals, we now proceed to their arrangements, that is, to the works of humanity. Let's start with the landscape."

34 Wolfgang Kemp, "Die Landschaftsphotographie August Sanders" [Landscape Photographs of August Sander] in *August Sander. Rheinlandschaften, Photographien 1929–1946*. Munich: Schirmer/Mosel, 1981 (First ed., 1975), p. 42.

35 The description dates back to a 1975 exhibition at the International Museum of Photography, George Eastman House, Rochester, in which photographs by Robert Adams,

Lewis Baltz, Bernd and Hilla Becher, Joe Deal, Frank Gohlke, Stephen Shore and Henry Wessel were shown. Cf. Britt Salvesen, *New Topographics: Photographs of a Man-Altered Landscape*, catalogue for tour of reconstruction of the ex-hibition by the same name by William Jenkens. Göttingen: Steidl & Partners, 2009.

[36] "I had fun with the orchid photography; the sight is just too grotesque. If it stays that way when a single blossom is enlarged? [...] By the way, if father wants to take similar photographs next spring, he should climb around the cliffs of the Landskrone near Remagen, where many unusual orchids grow." Erich Sander to August and Anna Sander, 14 Nov. 1937, document, REWE Library in Die Photographische Sammlung/SK Stiftung Kultur, August Sander Archive, Cologne.

[37] With the exception of an essay by Herbert Molderings, this misconception has emerged repeatedly in critical literature; cf., e.g., Anne Halley, "August Sander" in *The Massachusetts Review* 19:4, Winter 1978, p. 667. Cf. Herbert Molderings, "August Sander Rheinlandschaften" in *Kritische Berichte*, Vol. 3, Issue 5/6, 1975, pp. 120-131.

[38] Cf. Olivier Lugon, "August Sander: Landschaftsphotographien" [Landscape Photographs] in *August Sander. Landschaften*, Ed. Die Photographische Sammlung/SK Stiftung Kultur, Cologne, in tandem with exhibition by same name from Die Photographische Sammlung/SK Stiftung Kultur in the MediaPark, Cologne, as well as in the Landesmuseum Mainz, Munich. Schirmer/Mosel, 1999. pp. 26-27, 225.

[39] August Sander, "Programm für die Fortsetzung meiner Arbeit, 1952" [Program for the Continuation of my Work]. Document, REWE Library in Die Photographische Sammlung/SK Stiftung Kultur, August Sander Archive, Cologne.

[40] Cf. Walter Benjamin, "Kleine Geschichte der Photographie" in *Das Kunstwerk im Zeitalter seiner technischen Reproduzierbarkeit*. Frankfurt am Main: edition suhrkamp, 1977. p. 60.

[41] Adolf Meyer-Abich, ed. *Biologie der Goethezeit. Klassische Abhandlung über die Grundlagen und Hauptprobleme der Biologie von Goethe und den großen Naturforschern seiner Zeit: Georg Forster, Alexander v. Humboldt, Lorenz Oken, Carl Gustav Carus, Karl Ernst v. Baer und Johannes Müller* [Biology in the time of Goethe. Classical Treatise on the Principles and Central Problems in the Biology of Goethe and the Great Naturalists of his Time...]. Stuttgart: Hippokrates-Verlag Marquardt & Cie, 1949. p. 68.

[42] Cf. glass negative plate ASA 18 / 631, Die Photographische Sammlung/SK Stiftung Kultur, August Sander Archive, Cologne.

[43] "The Daguerrotype in its ultimate form belongs to one of the most precious treasures of photography. [...] In the subtlety of its lines, it is unsurpassed by the best photographic processes of modern times; it is objective in the best sense of the word and full of significance for the present day. The new perspective of contemporary photography is based upon it." August Sander, "Aus der Werkstatt des Alchemisten bis zur exakten Photographie" [Lecture 1] in *Wesen und Werden der Photographie*. p. 8, 1931. Document, REWE Library in Die Photographische Sammlung/SK Stiftung Kultur, August Sander Archive, Cologne.

Photography as a Universal Language

A LECTURE BY AUGUST SANDER

The following original manuscript of a radio lecture by August Sander was revised slightly owing to confusing expressions.

As noted in his agreement with Cologne's broadcaster Westdeutscher Rundfunk (WDR), August Sander delivered his lecture on Sunday, 12 April 1931, from 8:30 to 8:55 am. On the back of the agreement, conditions are listed that give an indication of the technology common to the day and that make clear that the broadcast would be "live". Punctuality is requested, as is respect for the agreed-upon time limit; the speaker should also refrain from deviating from the submitted manuscript. And finally: "Speak as in normal life."[1] It follows, then, that this text was not for publication but rather served as the basis for a lecture.

In total, August Sander gave six radio lectures in March and April, 1931, under the title The Essence and Development of Photography. *Alongside the fifth lecture presented in its totality here, the other lectures were: 1. "From the Alchemist's Lab to Exact Photography", 2. "From Experiment to Practical Use", 3. "Photography at the Turn of the Century", 4. "Scientific Photography", and 6. "The State of Contemporary Photographic Praxis". The fifth lecture, "Photography as a Universal Language", was translated and published along with commentary by Anne Halley in 1978 in* The Massachusetts Review[2]; *in German, it has only been published in excerpts. The entire lecture series is currently being edited and prepared for publication by Thomas Schatz-Nett in the context of his dissertation. Recordings are no longer available in WDR's archive.[3]*

In contrast to the animal kingdom, human society is constantly undergoing a process of development. One can understand, then, why humans themselves continually change in order to adjust to their living conditions, because no other creature on earth is subjected to changes in its surroundings as diverse as those confronting humanity. Humanity has constantly been compelled to solve the problems arising from altered surroundings. But the human intellect, distinct from that of other animals, is also that which drove humans to dominate all other creatures. With the invention of the first tools, humans recorded their first victory over animals. The emergence and development of language also probably arose out of human needs.

With the development of language, an immensely strong means of social cohesion was achieved, a formidable intensification and a clear awareness of social instincts. The first verbal understanding may have arisen from group formation, and we label this verbal understanding with the term "dialect". Because humanity was exposed to constant danger, social reasoning took hold—and with it, language. Because people were constantly separated by time and space, it was necessary to communicate with each other via signs and thereby to maintain a connection from person to person, group to group, time to time—because sound was fleeting, which is to say: it wasn't present […]. Before the origin of written language, there was pictorial language, which served primitive humans in the separation of space and time. Confirmation of this is already available from the ice age, the age of cave dwellers, the ancient Egyptians, the blacks, etc. Christendom, too, in its early days availed itself of the language of forms to communicate and propagate the teachings of Christ.

After the awakening of a child's consciousness of the ego, the imagination of things is wakened and stimulated by pictorial language. Aside from sound, pictorial language is the only possibility of communication for illiterates. Similarly, for the masses, it is the most suggestive medium for advertising or coming to an understanding or achieving an end, because the image provides faster orientation than written language. And it isn't tied to a group or linguistic boundary, the way words are. We all know what kind of impression an image can provoke, be it of a cheerful or serious nature. Our attention to pictorial language has regained its strength thanks to the invention of photography, which has worked its way up as a popular form of communication unfettered by the linguistic borders that limit the use of sounds. Via photography, we are capable of conveying facts, our thoughts and our ideas to all the peoples of the world; add a date to it, and we're capable of capturing world history. Let me begin with a few examples.

A photo of the sky, be it of the sun, moon or stars, would be comprehensible even to the most remote man living in the bush. In the realm of biology, in the animal or plant kingdoms, the photo as pictorial language can also serve as a means of communication without the aid of sound. But the realm in which photography has its greatest expressive power—and which language will never be able to equal—is physiognomy, which we will not focus on until the second part of the lecture. Our eyes convey to us a surface image of things around us, and the mind processes the viewed objects into ideas and creates an inner world that we interpret in the most varied of ways. Thus we arrive simultaneously at the distinction between Good and Evil—in humans or animals—, recognize danger, and perceive beauty or ugliness or fear. We are capable of depicting all of these sensations in photographs and of making ourselves comprehensible by photographic means. We proceed to serial photography, to film, by means of which we become acquainted with the most hidden processes in the life of plants. An apt

popular expression: "Watching the grass grow"—a reality thanks to photography. We have already begun to record human development using photography, tracking every phase from embryo to death.

In my last lecture, I mentioned the scientific collaboration that has allowed 18 observatories to take 20,000 photographs of the sky for mapping the heavens. Here, the photograph speaks a language of high culture that is broadly understandable; the photo would speak another, equally powerful language if, in each of the 365 employment agencies in Germany, one would simultaneously photograph the people there and join the results together, tagged with the year 1931. The tragedy of this photographic language is probably understandable—and without any commentary—for all of contemporary and future humanity. No language on earth can speak such a broadly comprehensible language as photography provided that 1., we observe precisely the chemical-optical-physical path towards proving the truth, and 2., we master physiognomy, though of course one must be clear as to whether he wants to serve culture or commerce. I'd like to mention yet another process: For example, the press is now preparing the population for the coming, bestial use of gas warfare and is recommending gas masks to protect the lives of the uninvolved populace.

It suffices here to photograph an infant alongside a gas mask instead of her mother's breast and to label the image in turn with a year from the twentieth century. Here, the photo would not only constitute the capturing of contemporary history but would also express in a broadly understandable way all the brutality of the inhuman mind. I don't mean to say that life and death, descriptions and experiences, can only be rendered photographically. That would be presumptuous nonsense. The ability of the written and spoken word to serve such ends is not just a potential but rather something that has long been proven. But with civilization's progress, verbal expression has become increasingly complicated and abstract and requires a greater level of knowledge and intellectual training in order to be understood. In contrast, photographic presentation enjoys the advantage of immediacy and vibrant clarity. While, in the age of intellectualism, literary accounts attune themselves more and more to the interests of an intellectual elite, photographic representation readily suits itself to the perceptiveness of the broadest masses and their more limited intellectual training. As far as that goes, I believe I'm generally on the right track in maintaining that no national language on earth could replace or surpass photography in its significance as a global language. Photography is already the primary pictorial language, be it a picture taken from a distance or a film; this is the case because of its general comprehensibility for the masses and all the peoples of the entire world. In photojournalism, for example, it has long been a global language, communicating events to us far more powerfully than the word. The illustrated newspapers, with circulations in the millions, are testament to this—though they admittedly speak their

own kind of language. Photography can also deceive us with so-called "double speak" or lies—so successfully, in fact, that the written word recedes to the background. In the World War for example, I saw a photo depicting a German soldier cutting the throat of a French child, and other similar photos. They were so deceptive that only an expert undertaking a thorough examination could determine that they were fakes.

But as a pictorial language, its effect was not lost, because the French people believed in the manual, deceptive authenticity of these pictures as a result of their photographic technique. Aside from the aforementioned instances, I should not neglect to mention that all means of expression are available to us by means of photography. With photography, we're capable of telling the truth, but also of spreading lies; we can communicate the language of all life and existence, from land to land, from person to person. The linguistic border is eliminated thanks to photography's general comprehensibility. I hope this brief exposition has made clear the significance of photography as a global language. Thus, the call for making it a topic taught in schools, in establishments for cultural and adult education, is not only justified but rather essential in order to enlighten people here about the light and dark sides of photography; beside its significance as proof of truth, photography also has at its disposal the most dangerous potential for deception. It is not only capable of enlightening. It can also cause the greatest confusion. The original thought behind my photographic work, "Menschen des 20. Jahrhunderts" [People of the Twentieth Century], which I started in 1910 and which comprises around five or six hundred photos, of which a selection was published in 1929 under the title "Antlitz der Zeit" [Face of Our Time], was nothing other than an avowal of faith in photography as the global language. And it was an attempt at creating a physiognomic momentary portrait of the German, built upon the chemical-optical devel-opment of photography, which is to say, upon the pure design of light. And here we come to the second part of my lecture, which will deal with physiognomy in photography. What is physiognomy, then? Physiognomy is above all insight into human nature, an innate gift of human intelligence that some of us possess in abundance, others less so. Here, it's necessary to introduce some examples.

We meet someone for the first time and get an impression of him. He is either good or bad, which is to say, we find him likeable or unlikeable, we feel a connection with him or we don't. This emerges from an innate feeling. It's evident in childhood; even animals have an instinct for such things. Almost without exception, we find this feeling in the female gender; in men, it's less often present, but it becomes sharper and more incisive by means of an approach more intellectual than that taken by the more instinctive female. Via nurture and interaction with other people, it can be trained until it becomes a special and elevated skill. Everything that happens has a face, and the total expression of this is called physiognomy.

The skill I'm talking about can be an inborn talent, or it can be developed by upbringing. We know that light and air, activity and predisposition shape individuals, and we distinguish them by virtue of their appearance. The impression a face makes tells us immediately what kind of work a person does or does not do; we also discern if a person is perplexed or happy, because life inevitably leaves its marks. As a poem tells us: "In every face, a story clearly written comes to stand; one person sees it, another—can't."[1] The features are runes of a new and yet also ancient language. The human gaze naturally belongs to physiognomy as well; comprehended far more strongly and quickly, more convincingly than the word, with one glance we can win people over or repel them. As is commonly said: "One look says it all." It's also commonly believed that there are people afflicted with a special look, the so-called evil eye; in this regard, Wilhelm von Humboldt once said that those sort of occult activities are not to be reduced to mere superstition but rather have an element of truth in them.

We find confirmation today in hypnosis. Because the individual does not make contemporary history but rather shapes the expression of his time and expresses his attitude, it is possible to capture a physiognomic portrait of an entire generation and to give it linguistic expression in a photograph by means of physiognomy. This portrait of time becomes even more comprehensible when we line up photos of types from the most varied groups in human society. Consider, for example, the parties in a nation's parliament; if we start with the right-wingers and move gradually towards those furthest to the left, we already have a partial physiognomic image of the country. These groups can then be divided into sub-groups, clubs and associations, but they all carry in their physiognomy the expression of their time and the attitude of their group, and this is especially the case with particular individuals. We describe such persons with the word: "type". We can make this determination in athletic clubs, among musicians, or in business associations and the like. Here, the photographer is indisputably capable of giving linguistic expression to a portrait of the time by virtue of his ability and physiognomic knowledge. Let me also furnish a counterexample here. We photograph someone of our era in his milieu in antique, medieval or Biedermeier clothing; we will not succeed in conveying anything even close to authenticity. We will always find a photographic expression corresponding to the person from the twentieth century. We thereby see that a person also leaves his stamp on his era, whereby the photographer gains the possibility, by means of his camera, of capturing a physiognomic portrait of the era. A person's traits consist not just in his face but also in his movement. Again and again, it is the photographer's task to stabilize or record this characteristic movement, which then, in a single image, offers a consummate reflection of his physiognomy.

The individual stands in the foreground of all events because it is he who creates the view of the world, aside from the higher powers. Thus having depicted the physiognomy of in-

dividuals, we now proceed to their arrangements, that is, to the works of humanity. Let's start with the landscape. Here, too, humans leave their mark through their works, so that, as with speech, landscape develops according to needs; in this way, humans often change the results of biological process. In landscapes, too, we recognize again the human spirit of a time, and this can be captured with the help of the camera. The story is similar in architecture and industry as well as with all human creations writ large or small. Landscape as delimited by a common language conveys the physiognomic portrait of a nation in time. If we broaden our field of vision, we can travel this line of reasoning to arrive at something akin to the observatories' overview of space, arriving at a momentary portrait of earth's inhabitants that would be of profound significance in recognizing the development of all humanity. We must broaden our elucidations further still vis-à-vis the relation of photography to art, which I would like to clarify along the lines of the following aspects: One can snap a shot or take a photograph; "to snap a shot" means reckoning with chance, and "to take a photograph" means working with contemplation—that is, to comprehend something, or to bring an idea from a complex to a consummate composition. To succeed in this is to reach our goal. But the camera in itself certainly does not suffice for the execution of a photographic work of high quality. Canvas and paintbrush do not make a painter, let alone an artist, and a boulder and hammer by no means make a sculptor. On the other hand, the creator is always restricted by his medium, and so a photograph is not possible without the camera.

We have painting, music, architecture, sculpture, literature, photography, technology, mathematics and so on. The result of it all is "the work," and in each case a work conveys to us the language of its creator. In summarizing our elucidations about photography, we must come to the conclusion that we are dealing here with a special field that, as a result of the autonomous rules it follows, expresses its very own language. By means of seeing, observing and thinking, and with the aid of the camera and a date, we can capture world history and influence all of humanity by means of the expressive potential of photography as a global language. With this lecture, I would like to conclude my general observations on photography. In the two final lectures, I will deal with particulars about the photographic process and the current state of technology.

1 Westdeutscher Rundfunk A.G. to August Sander, 3 April 1931, Document REWE Library in Die Photographische Sammlung/SK Stiftung Kultur, August Sander Archive, Cologne.

2 Anne Halley: "August Sander." *The Massachusetts Review*, 19:4, Winter 1978, pp. 663-679.

3 Personal communication with Birgit Bernard at WDR's Historical Archive, 1999. Cf. Birgit Bernard, "August Sander und der Rundfunk", in *Zeitgenossen. August Sander und die Kunstszene der 20er Jahre im Rheinland* [Contemporaries: August Sander and the Rheinland Art Scene in the 1920s]. Ed.

Die Photographische Sammlung/SK Stiftung Kultur, Cologne. Texts by Birgit Bernard, Gertrude Cepl-Kaufmann, Anne Ganteführer-Trier, Wolfram Hagspiel, Klaus Wolfgang Niemöller, Louis Peters, Maria Porrmann, Gerd Sander, Eduard Trier and Arta Valstar-Verhoff, foreword by Susanne Lange and Hans-Werner Schmidt, Göttingen: Steidl, 2000, pp. 202–209.

4 Friedrich von Bodenstedt, Die Lieder des Mirza-Schaffy, 1851. "In jedes Menschen Gesichte steht seine Geschichte ganz deutlich geschrieben, der eine kann's lesen und der andere nicht."

Photographs

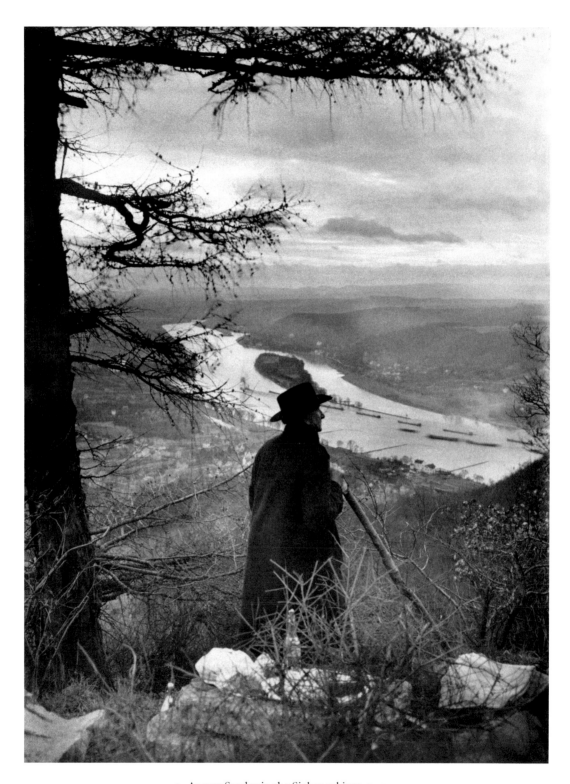

1 August Sander in the Siebengebirge, c. 1941

[…] Having reached the summit and cut a swathe […], the camera was set up. […] I was so astonished by the beauty of the landscape, […] the sky overcast with utterly magnificent clouds; and then the movement of people, of the landscape and of the train became visible. […] From this moment on, my enthusiasm for photography grew, and to this day it hasn't left me.

August Sander, "Chronicle of Portfolio 3, *Herdorf/Siegerland*", undated [1950s]

From early on in his career August Sander photographed landscapes, primarily the Rhine and the hilly area southeast of Cologne known as the Siebengebirge. It was not simply a matter of documenting them, as he was also intent on drawing attention to landscapes as a part of his work. To this end, beginning in the 1920s, he produced several portfolios of landscape images including the portfolio reproduced here in full: "Der Rhein und das Siebengebirge" [The Rhine and the Siebengebirge region]. He saw it as the "start of a new major project" which he approached in a similarly direct manner as his portraits. In the exhibition of the "Association of Cologne Specialist Photographers" presented in December 1930 in the city's Arts and Crafts Museum he essentially showed these landscape photos and in doing so made it clear to everyone how important this project was to him.

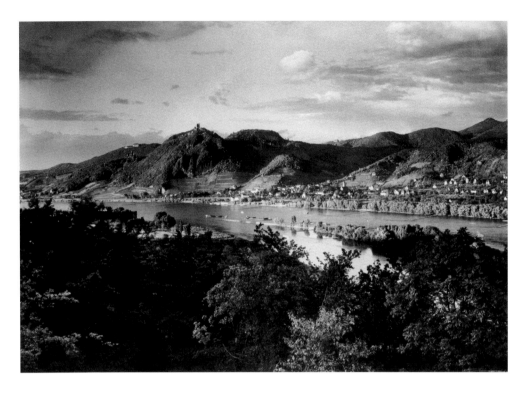

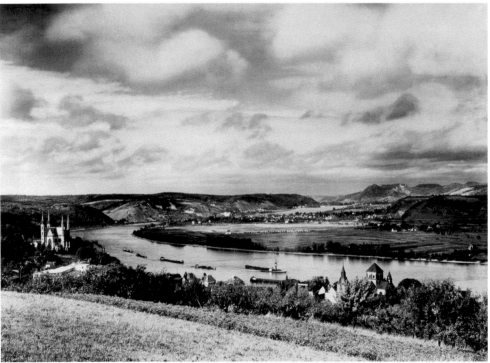

2 The Siebengebirge: View from the Rolandsbogen, 1929/30
3 View of the Siebengebirge from the Viktoria Mountain near Remagen, 1930

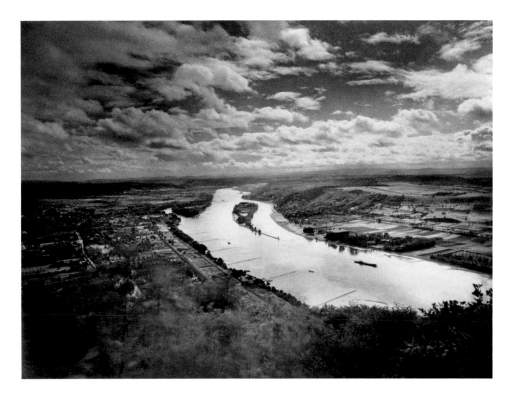

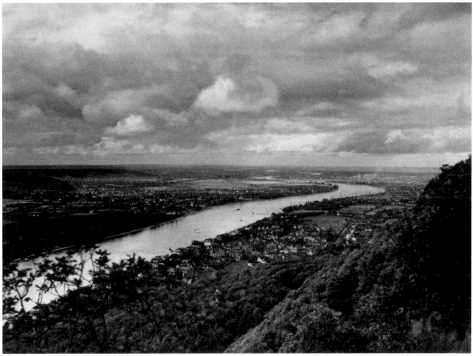

4 The Rhine Valley with Nonnenwerth Island, 1930
5 View of the Rhine Valley, Königswinter, Godesberg, Bonn and Cologne, 1930

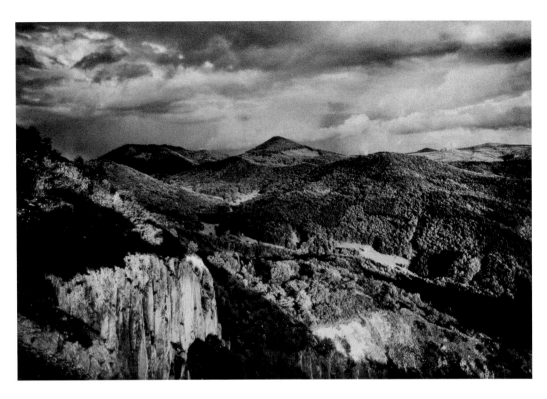

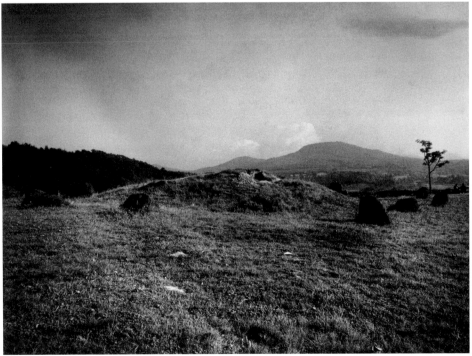

6 The structure of the Siebengebirge mountains, 1930
7 Thing site near Niederdollendorf, 1930

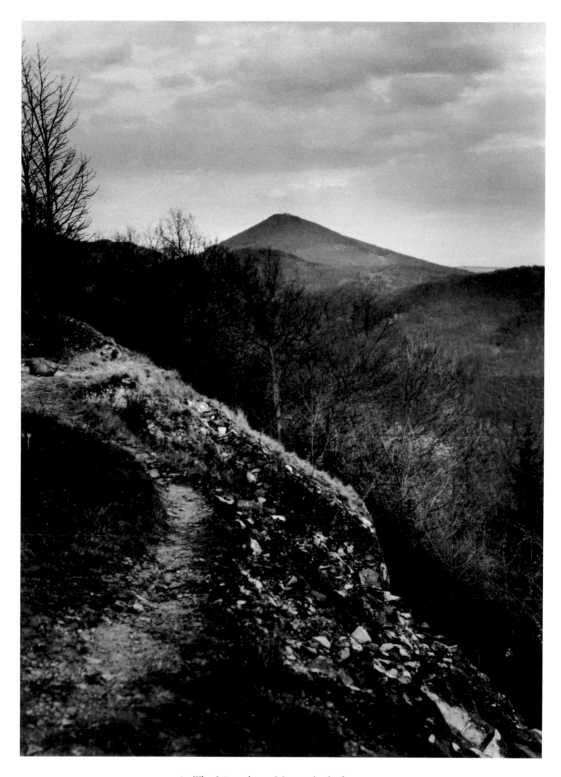

8 The Löwenburg Mountain, before 1934

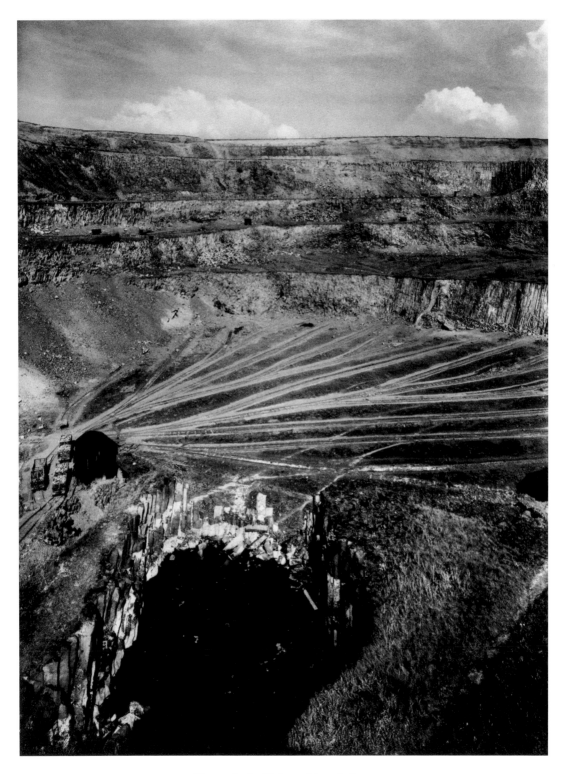

9 Quarry in the Siebengebirge, before 1935

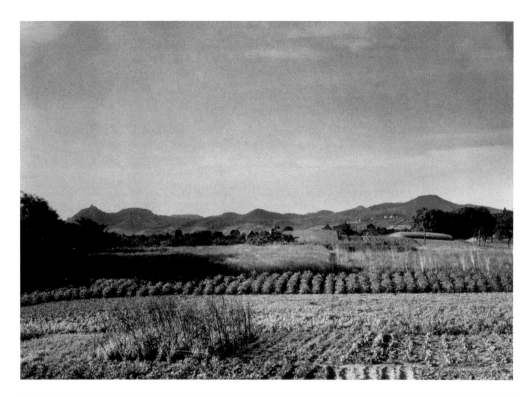

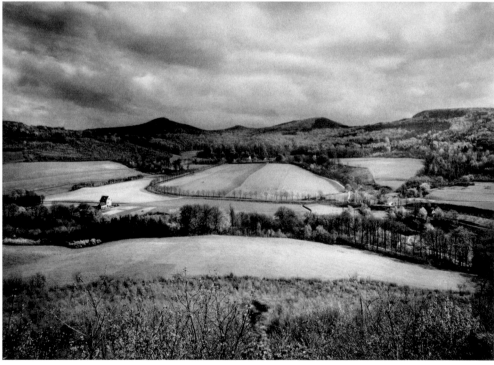

10 View of the Siebengebirge from Rheinbreitbach, before 1935
11 Area around Heisterbach, before 1934

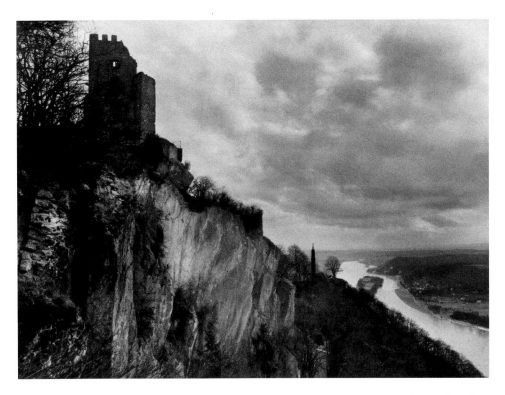

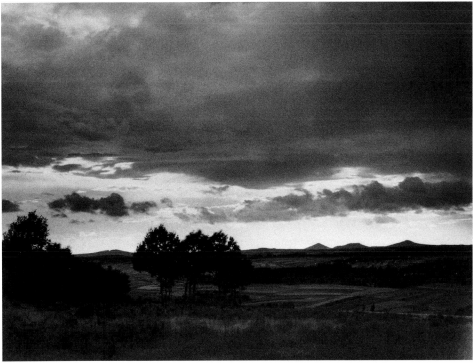

12 The Drachenfels in the Rhine Valley, before 1935
13 The Siebengebirge seen from the Heights of the Westerwald, before 1934

Let's start with the landscape. Here, too, humans leave their mark through their works, so that, as with speech, landscape develops according to needs; in this way, humans often change the results of biological process. In landscapes, too, we recognize again the human spirit of a time, and this can be captured with the help of the camera. The story is similar in architecture and industry as well as with all human creations writ large or small. Landscape as delimited by a common language conveys the physiognomic portrait of a nation in time. If we broaden our field of vision, we can travel this line of reasoning to arrive at something akin to the observatories' overview of space, arriving at a momentary portrait of earth's inhabitants that would be of profound significance in recognizing the development of all humanity.

August Sander, "Photography as a Universal Language", Lecture 5, 12 April 1931

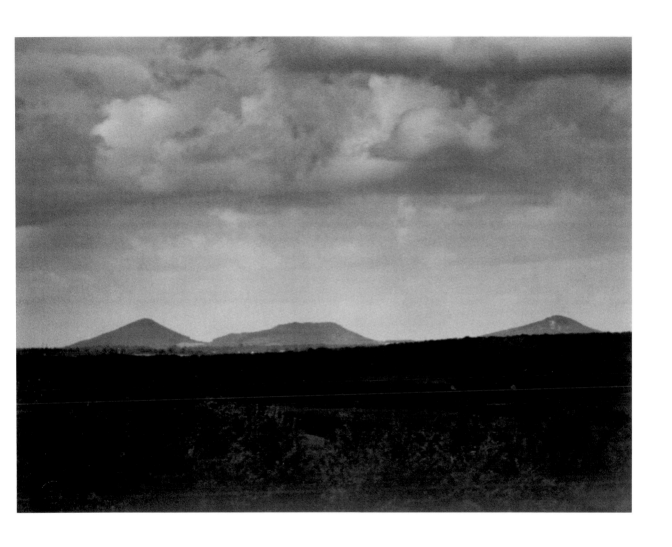

14 The Siebengebirge seen from the Westerwald, 1930s

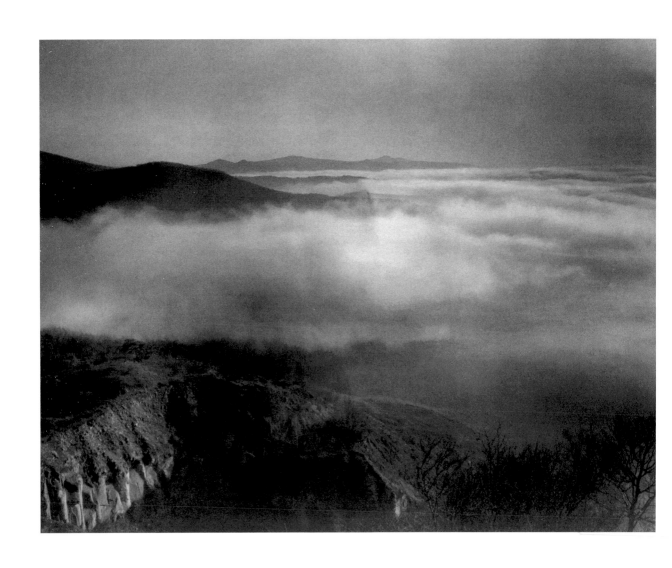

15 Siebengebirge, 1936

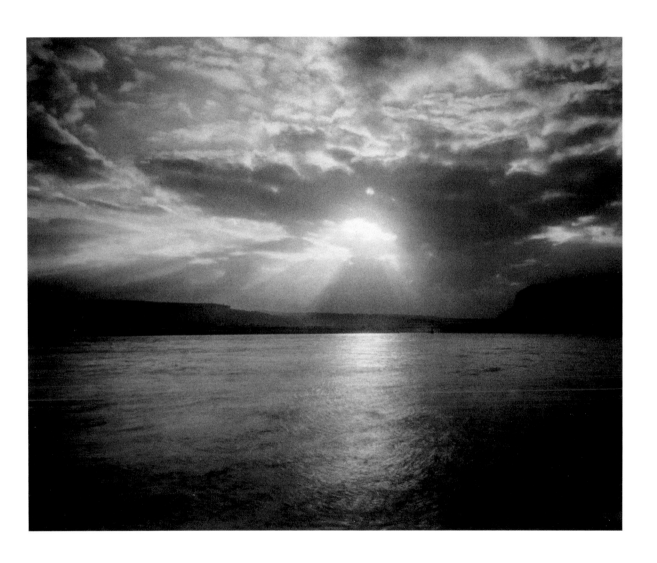

16 The Rhine near the Erpeler Ley rock, 1930s

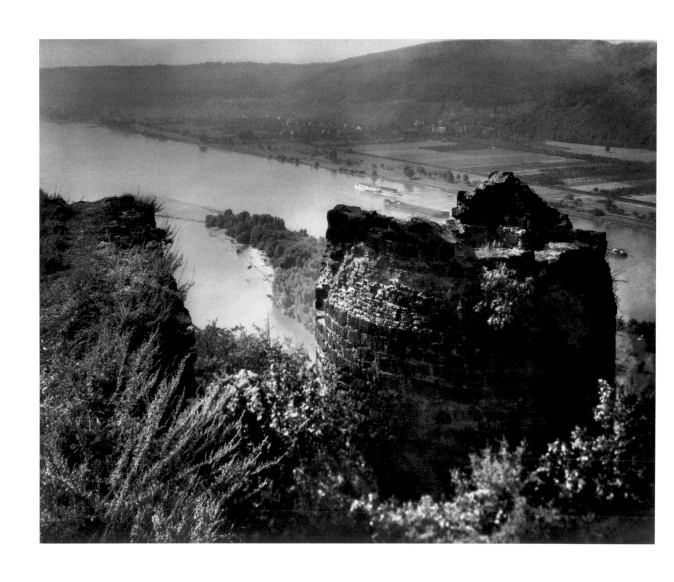

17　The Hammerstein ruins, 1930s

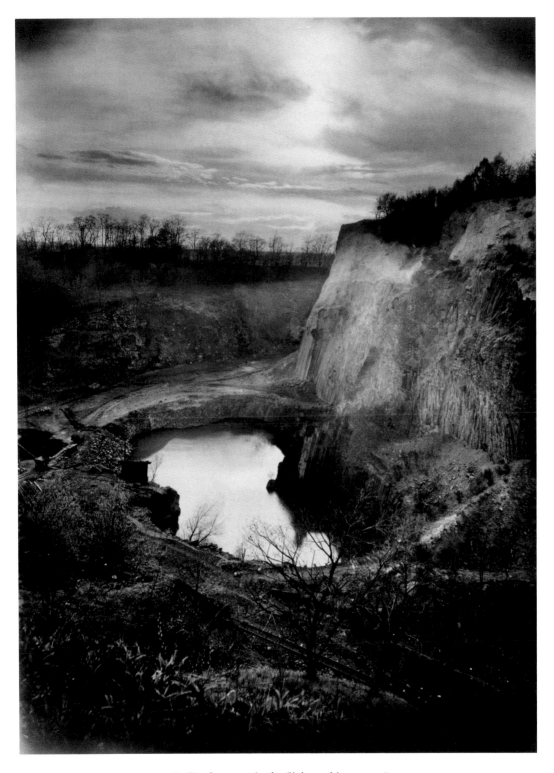

18 Basalt quarry in the Siebengebirge, c. 1938

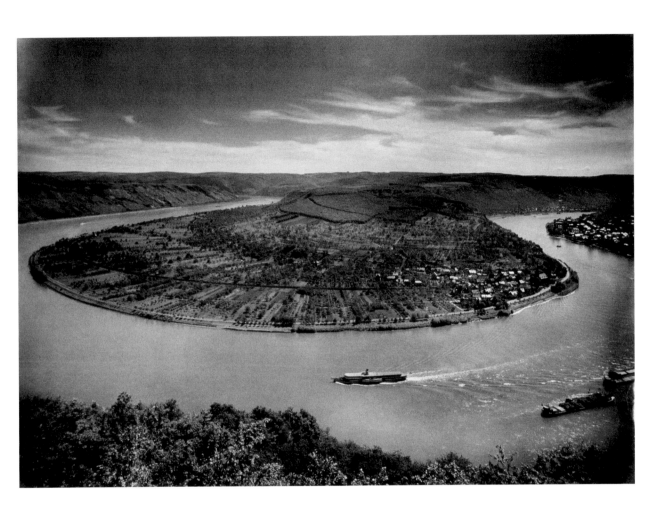

19 The Rhine loop near Boppard, 1938

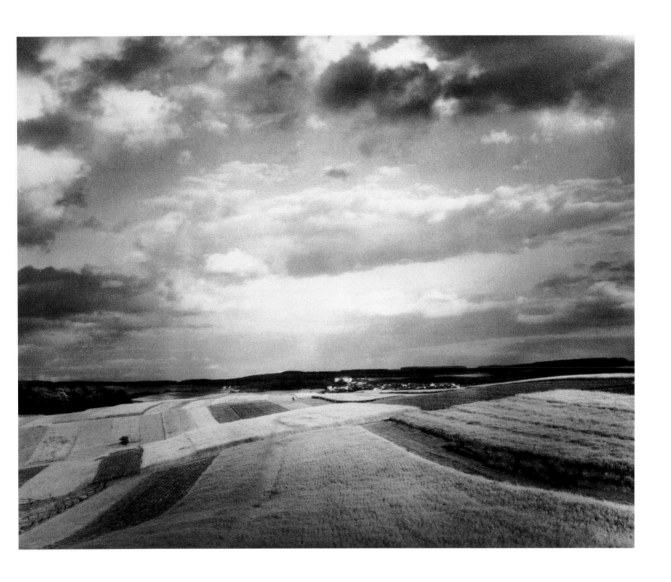

20 View of Heuzert near Kroppach, 1930s

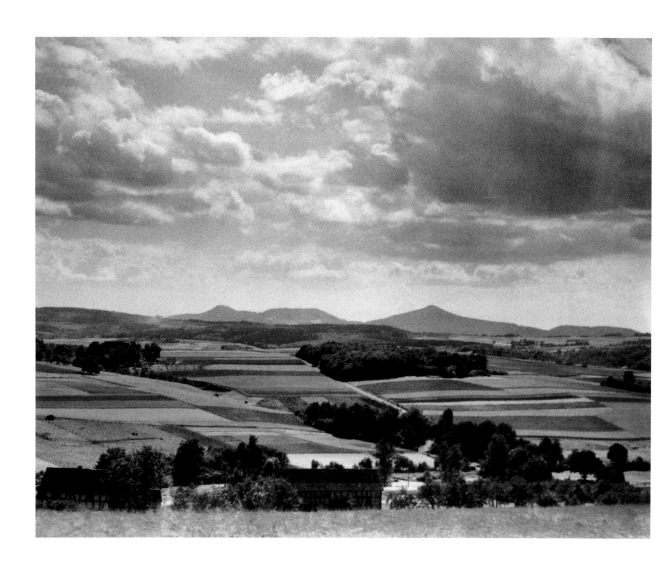

21 View of the Siebengebirge from Uckerath, 1930s

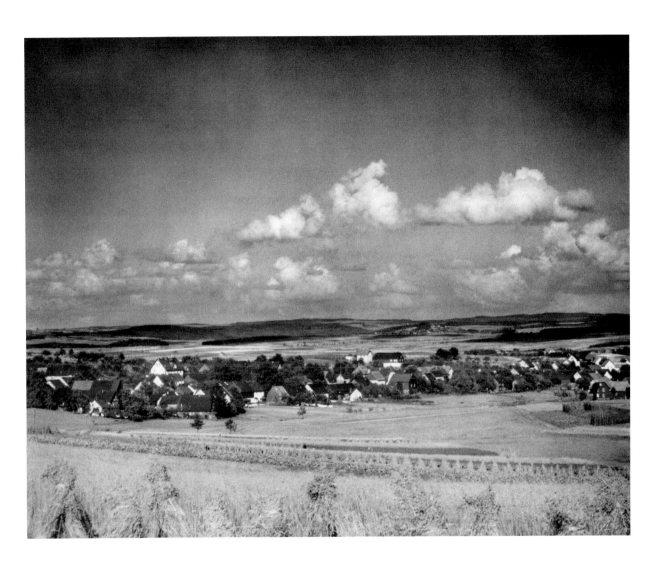

22 Borod near Hachenburg, 1930s

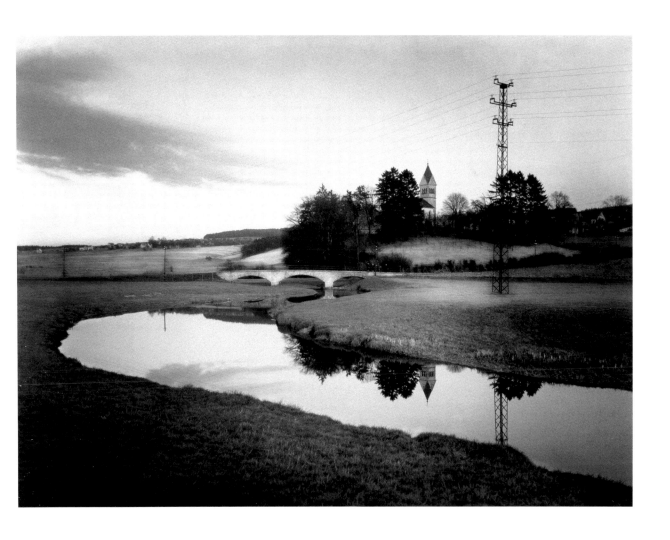

23 Wiedtal, Almersbach Church, 1930s

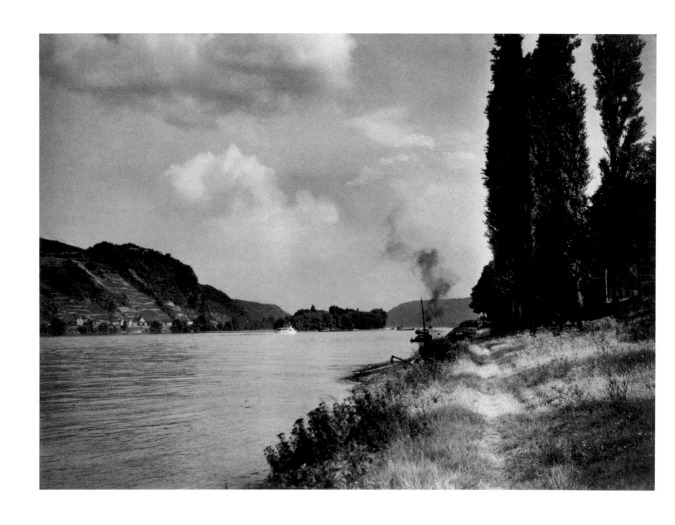

24 The Rhine near Bad Godesberg, 1930s

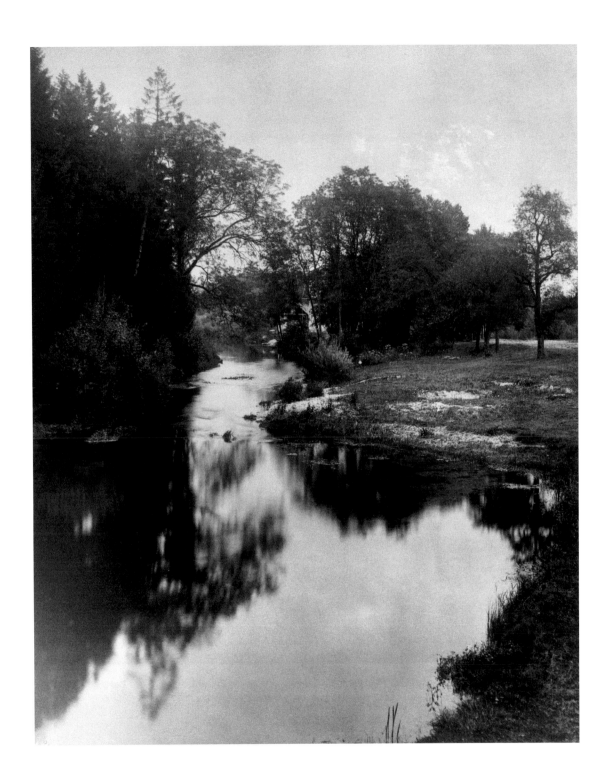

25 Stromberg, 1953

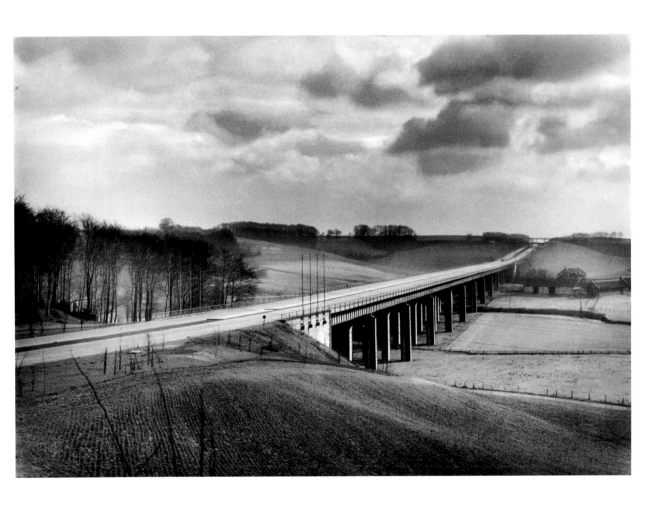

26 Neandertal Motorway bridge, c. 1938

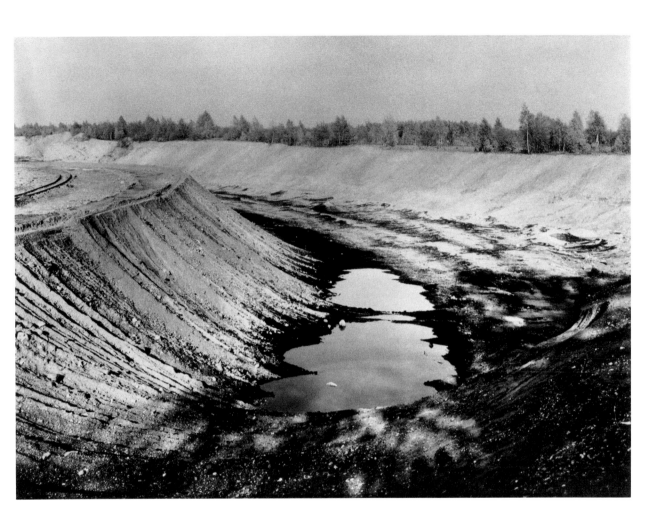

27 Lignite area near Euskirchen, 1928–1938

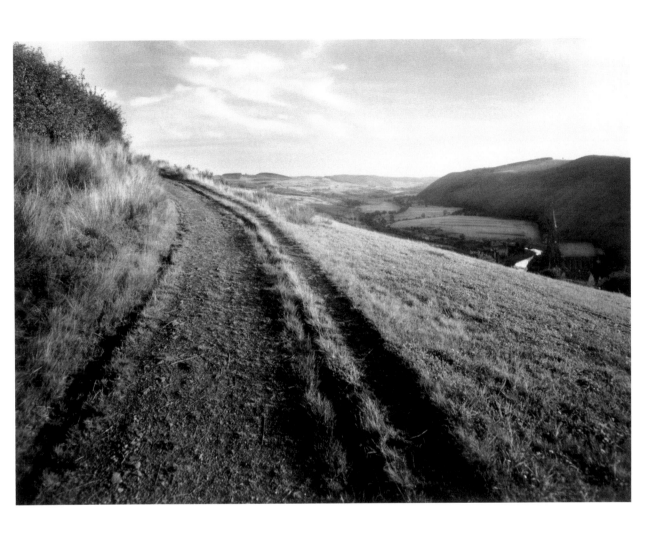

28 Gemünd/Eifel, c. 1930

One can snap a shot or take a photograph; "to snap a shot" means reckoning with chance, and "to take a photograph" means working with contemplation—that is, to comprehend something, or to bring an idea from a complex to a consummate composition.

August Sander, "Photography as a Universal Language", Lecture 5, 12 April 1931

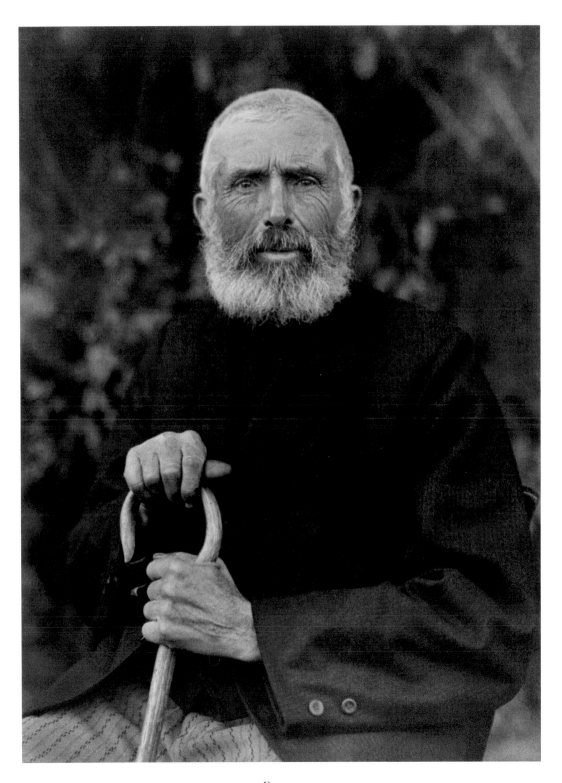

29 Farmer, 1910

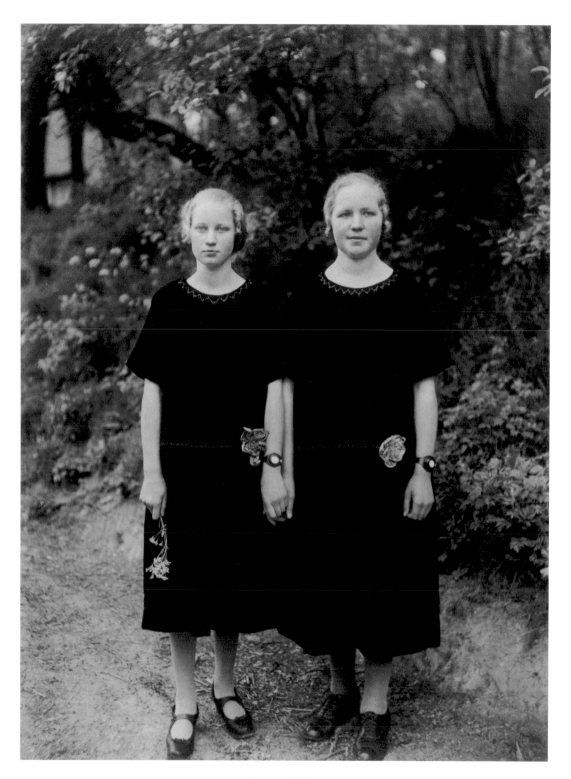

30 Country Girls, 1925

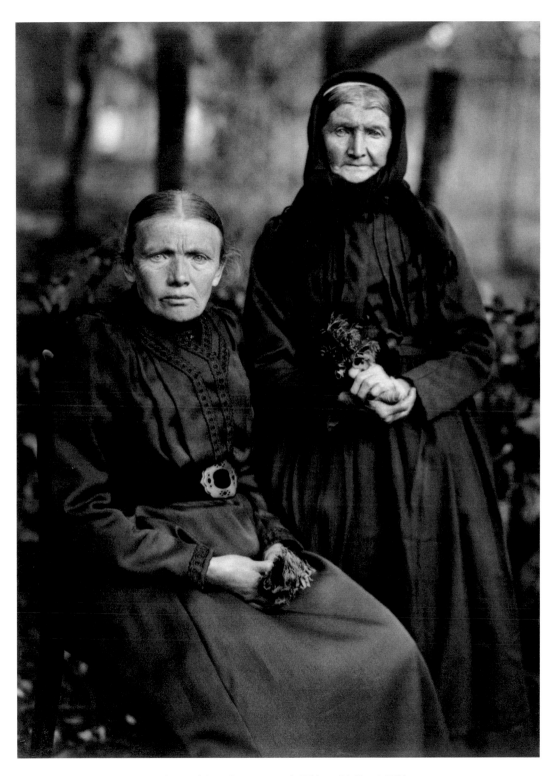

31 Mother and Daughter. Farmer's Wife and Miner's Wife, 1912

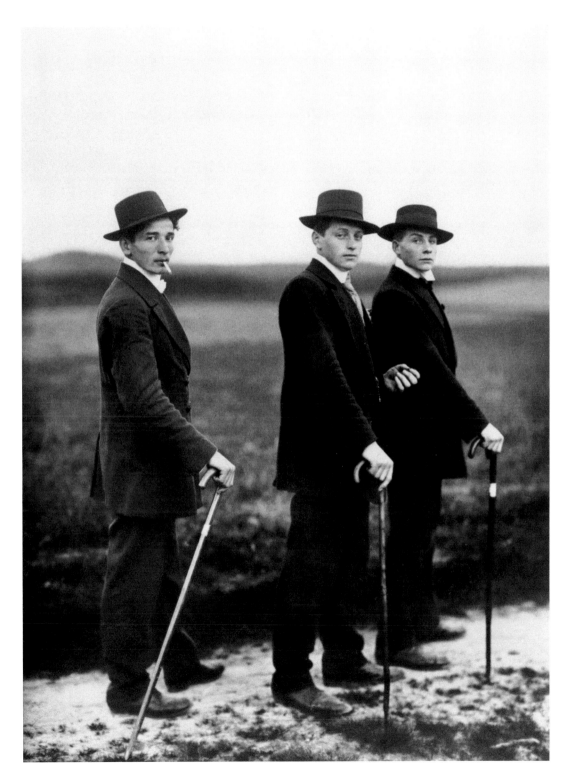

32 Young Farmers, 1914

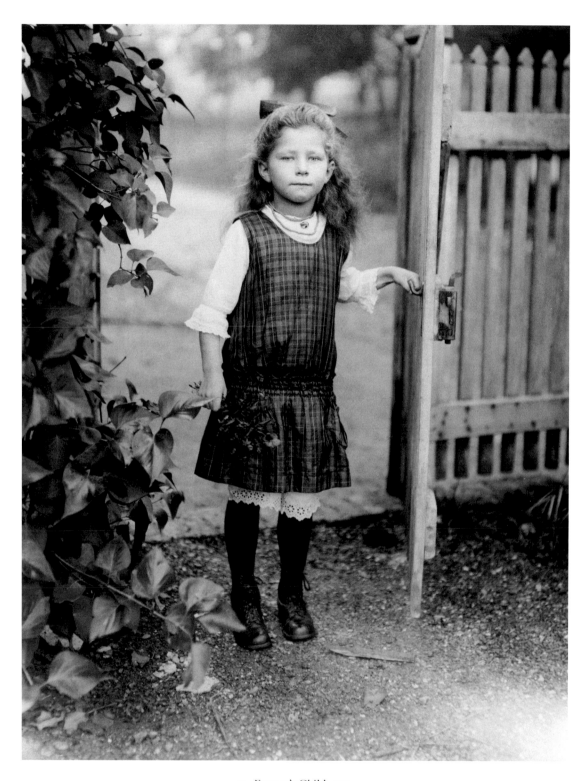

33 Farmer's Child, 1919

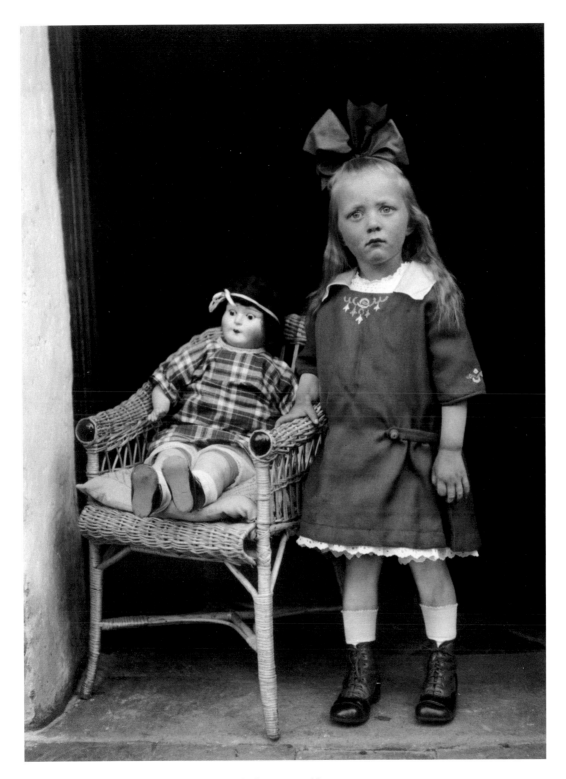

34 Girl, Westerwald, c. 1925

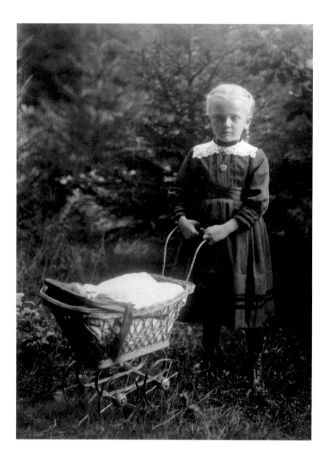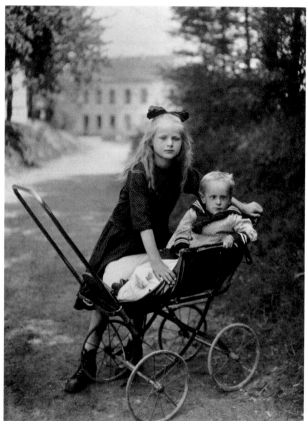

35 Girl, Westerwald, c. 1918
36 Children, Westerwald, c. 1922

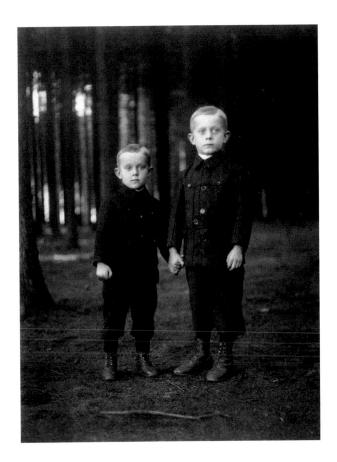

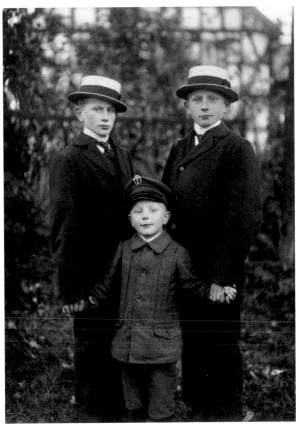

37 Brothers, Westerwald, c. 1918
38 Brothers, Westerwald, c. 1918

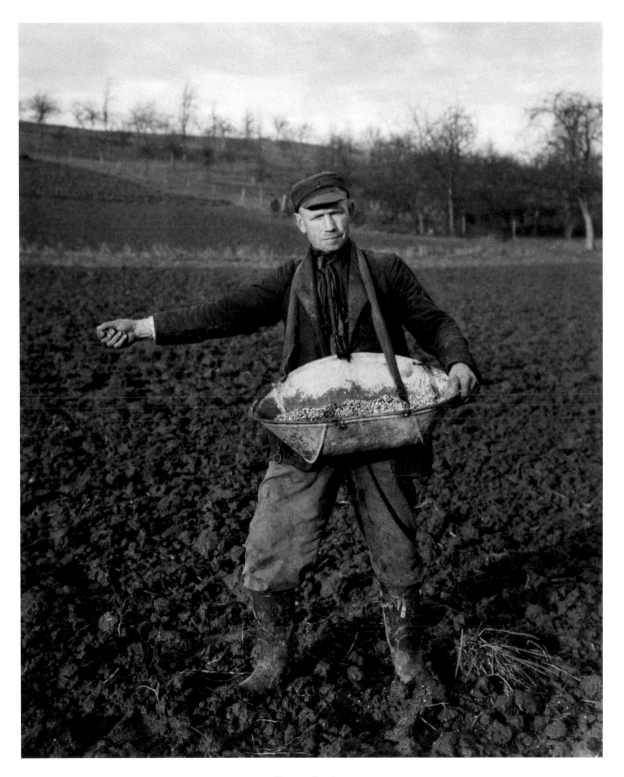

39 Farmer Sowing, 1952

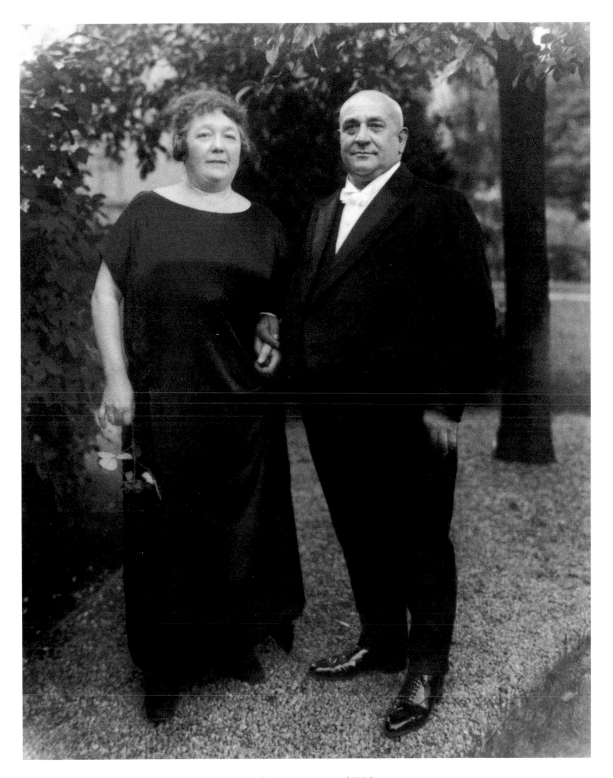

40 Gentleman Farmer and Wife, 1924

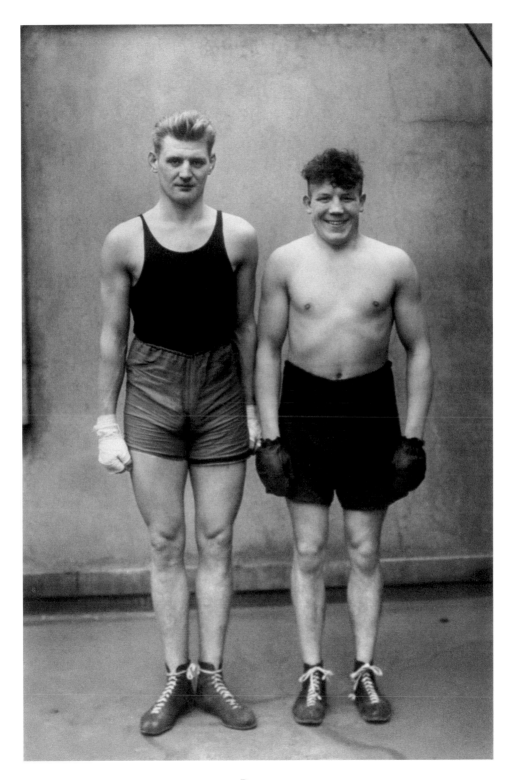

41 Boxers, 1929

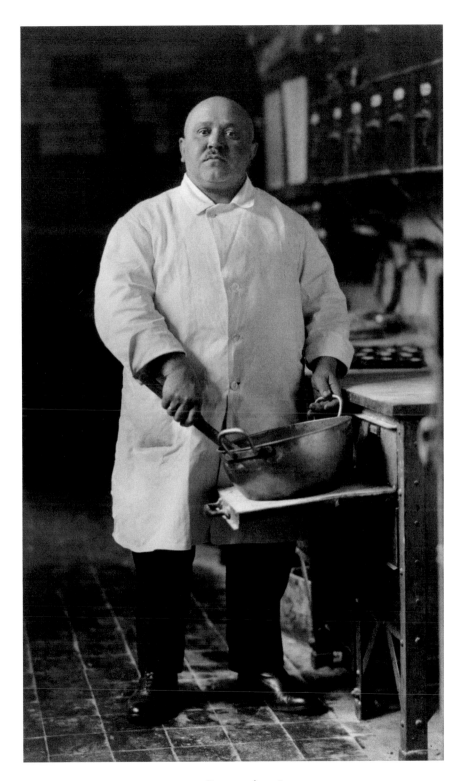

42 Pastrycook, 1928

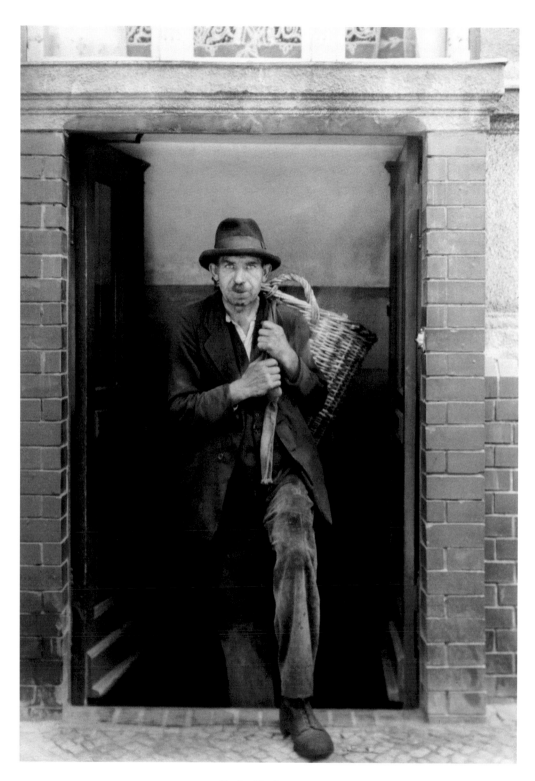

43 Berlin Coalheaver, 1929

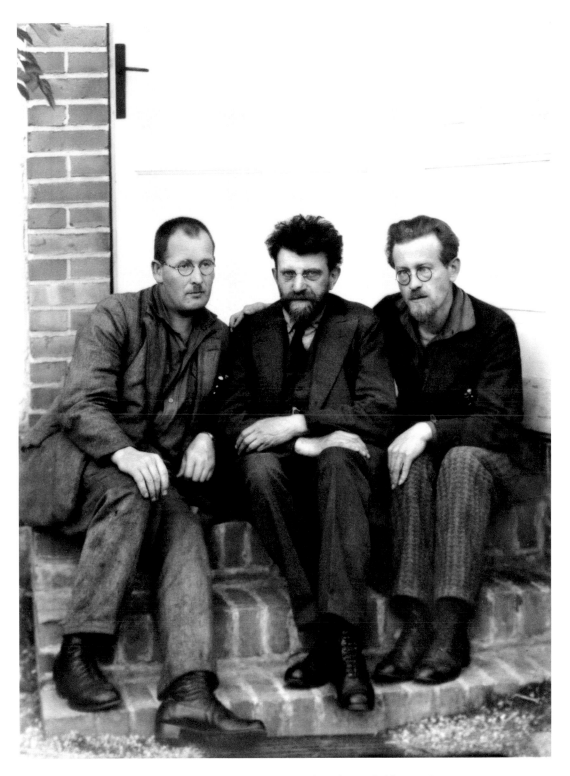

44 Revolutionaries [Alois Lindner, Erich Mühsam, Guido Kopp], 1929

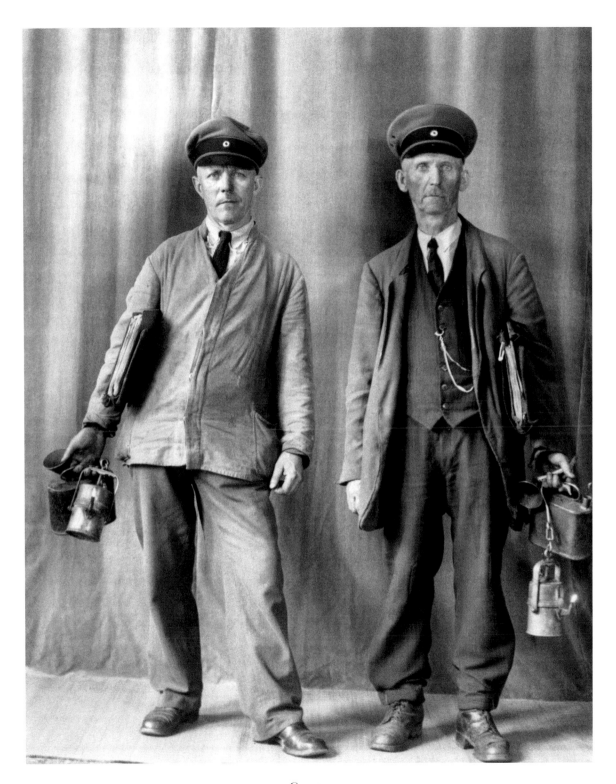

45 Gasmen, 1932

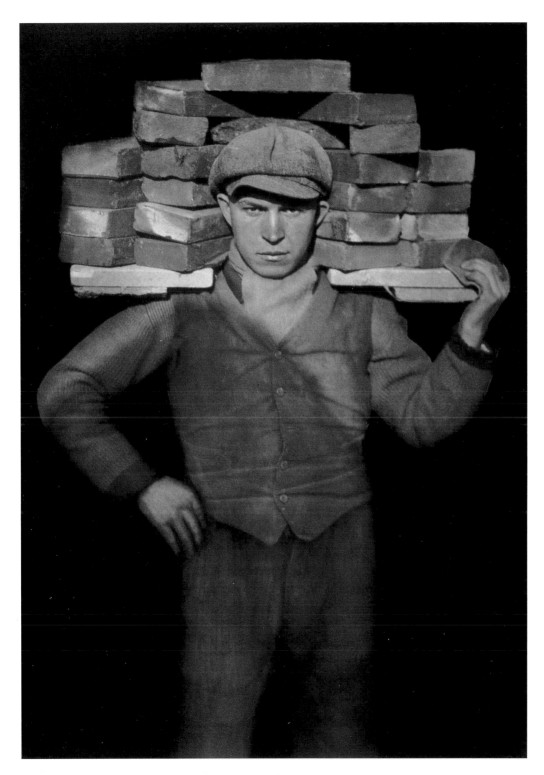

46 Bricklayer, 1928

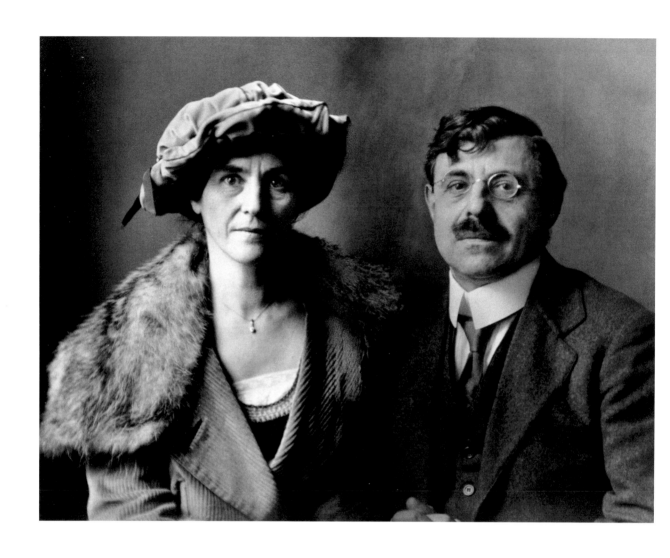

47 Composer and his Wife, 1920–1925

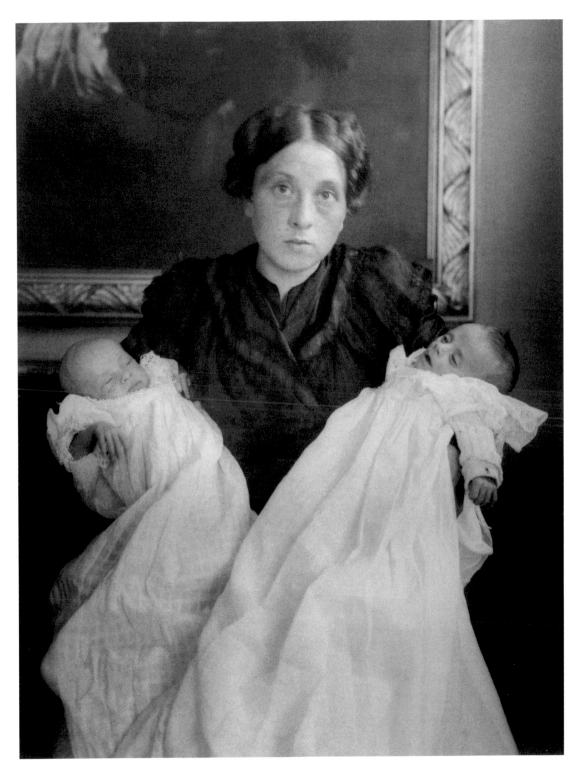

48 "My Wife in Joy and Sorrow", 1911

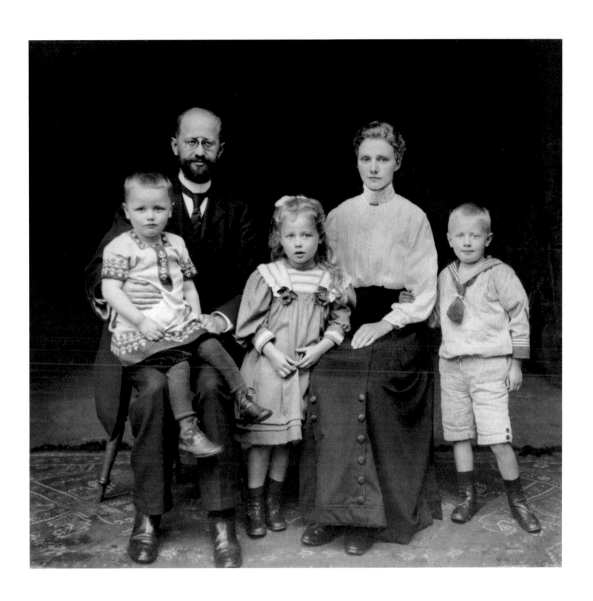

49 Village Pastor and Family, 1920–1925

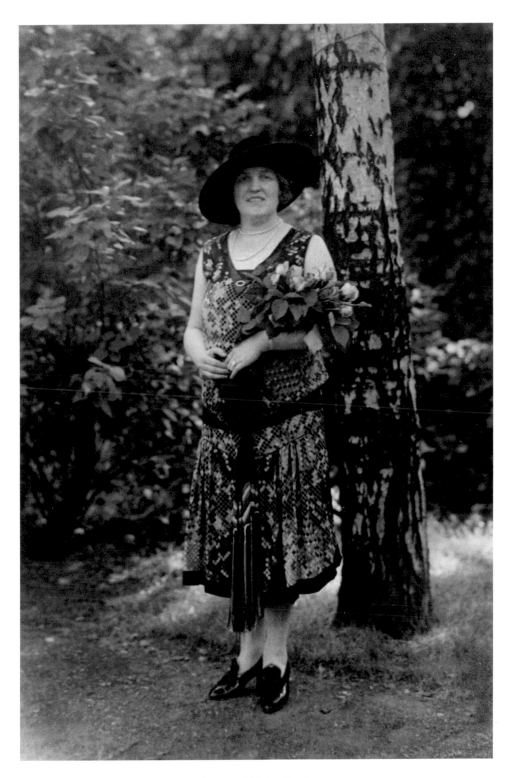

50 Soprano [Claire Dux], 1925

51 Architect's Wife [Dora Lüttgen], 1926

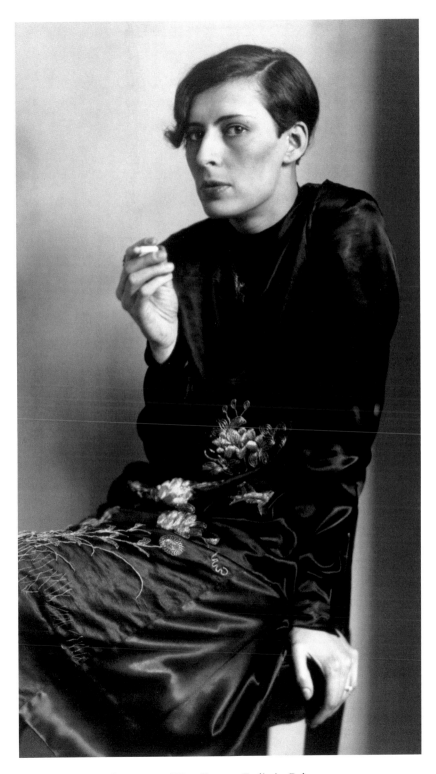

52 Secretary at West German Radio in Cologne, 1931

53 Secretary, 1945

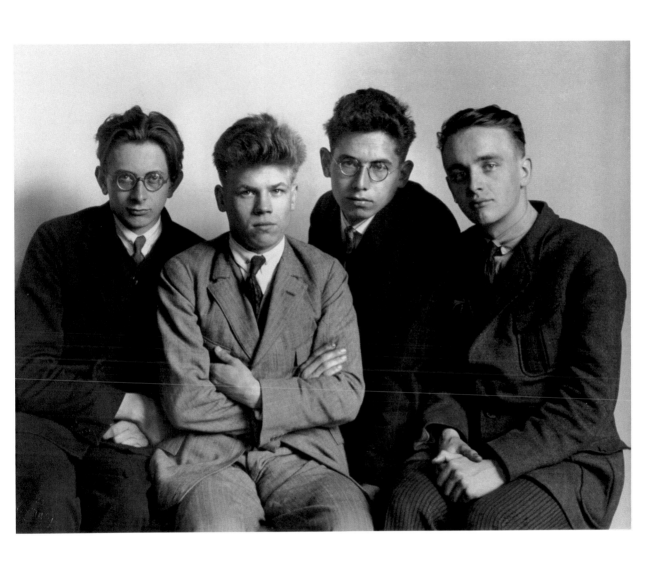

54 Working Students, 1926

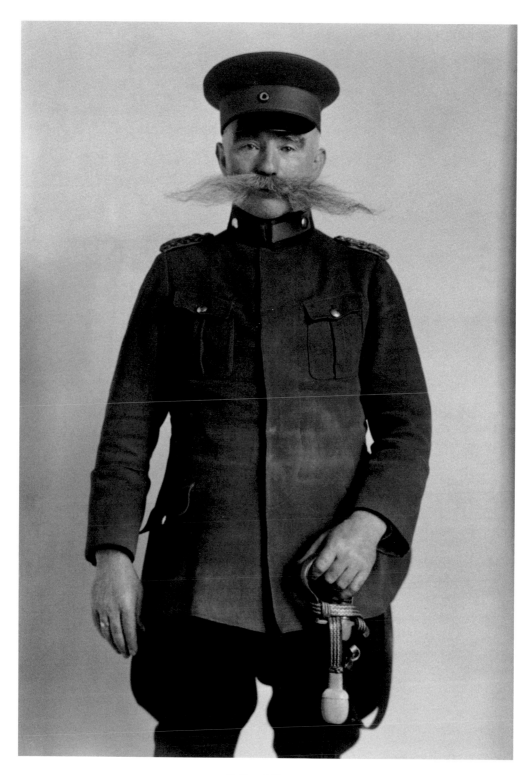

55 Police Officer, 1925

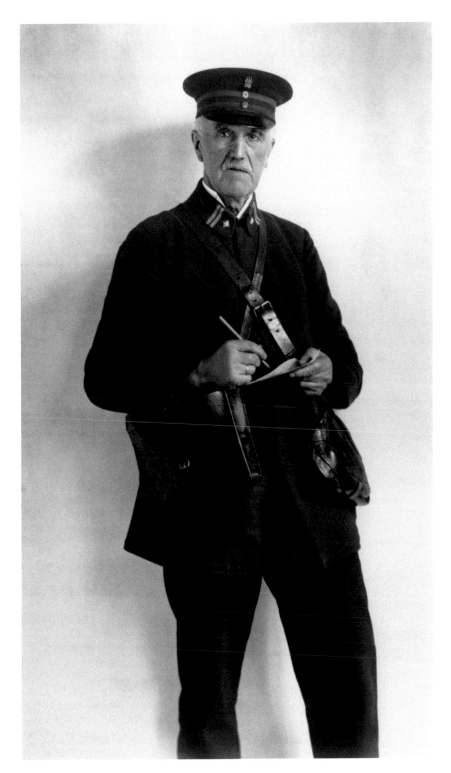

56 Court Usher, 1925

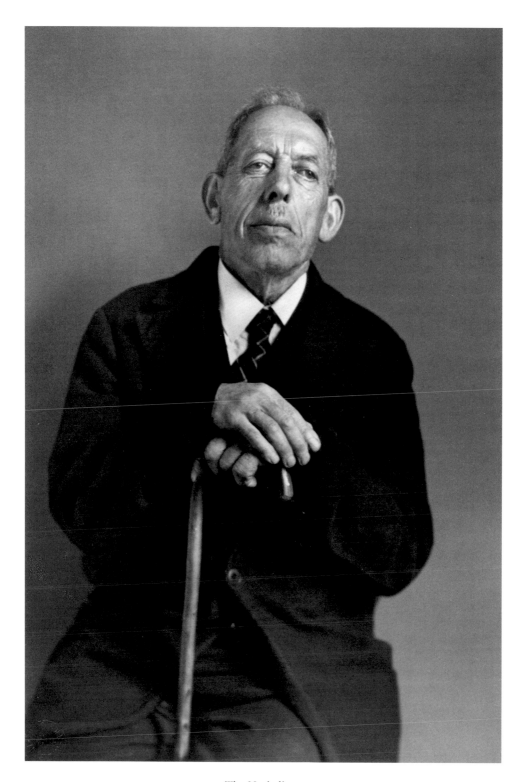

57 The Herbalist, 1929

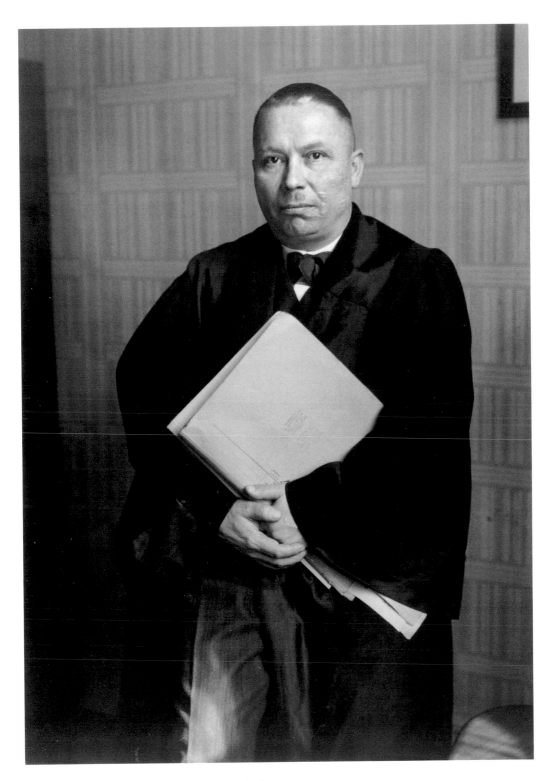

58 Attorney, 1932

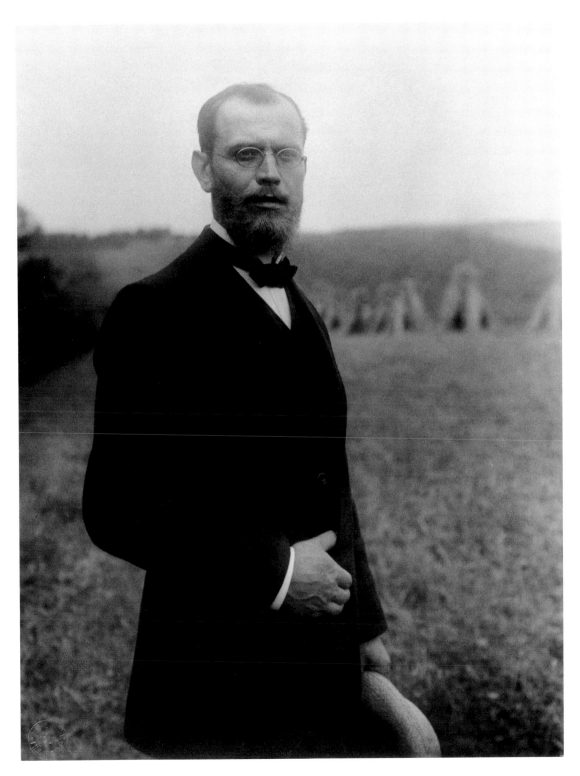

59 The Schoolmaster, 1910

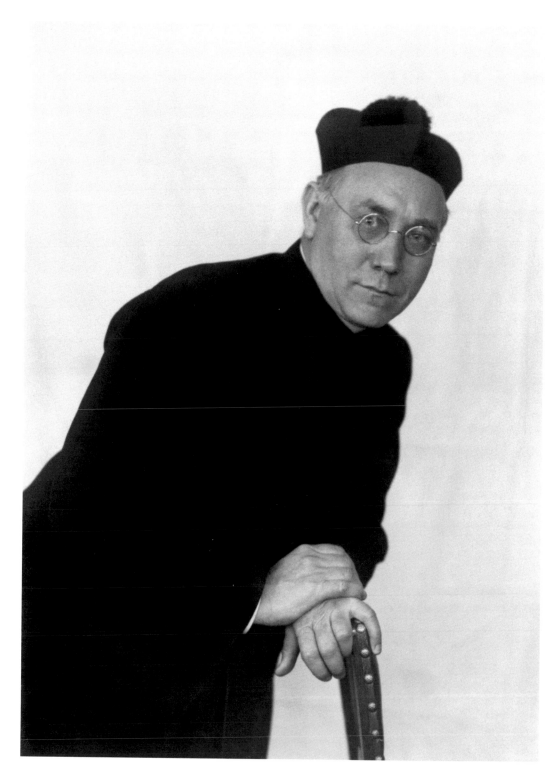

60 Catholic Priest, 1927

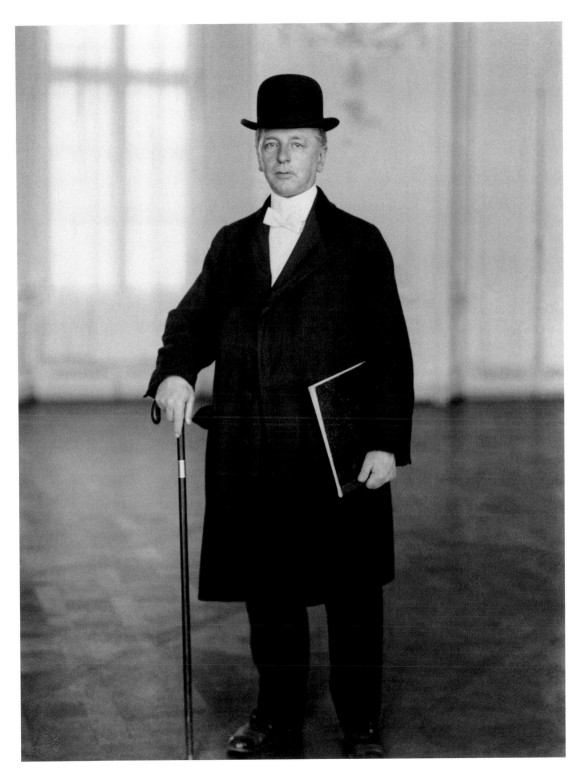

61 The Pianist [Max van de Sandt], c. 1925

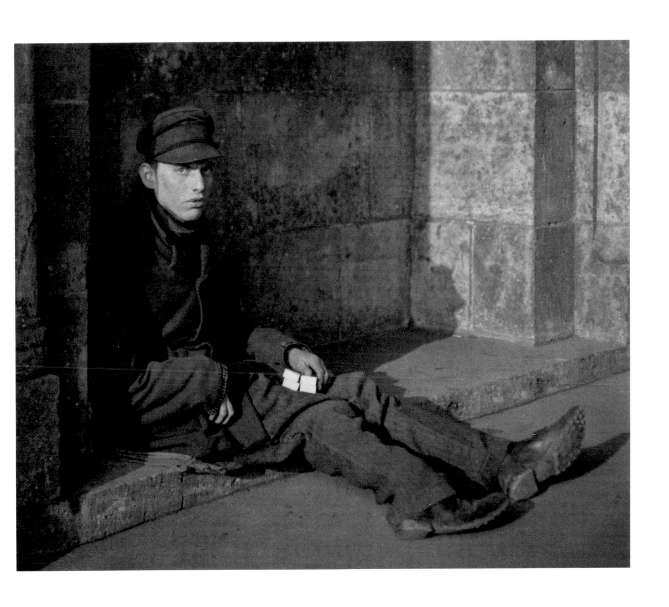

62 Match-seller, 1927

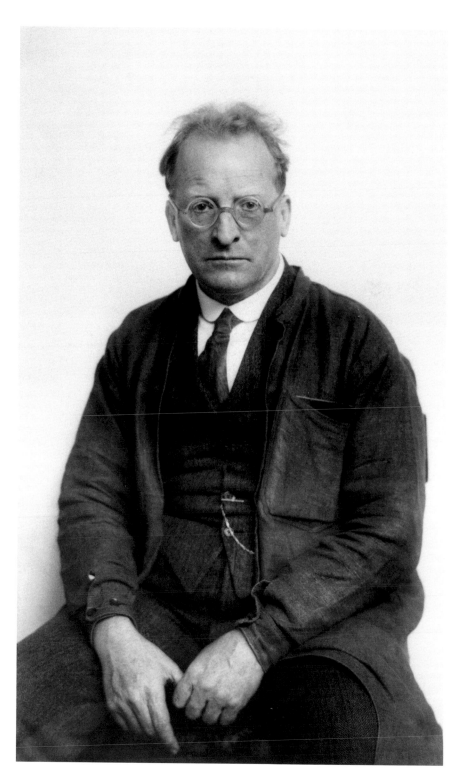

63 Architect [Richard Riemerschmid], 1930

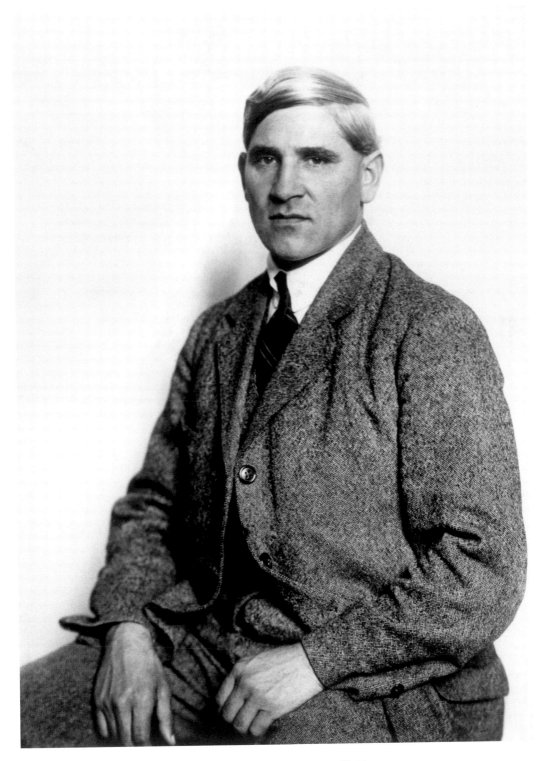

64 Painter and Sculptor [Otto Freundlich], c. 1925

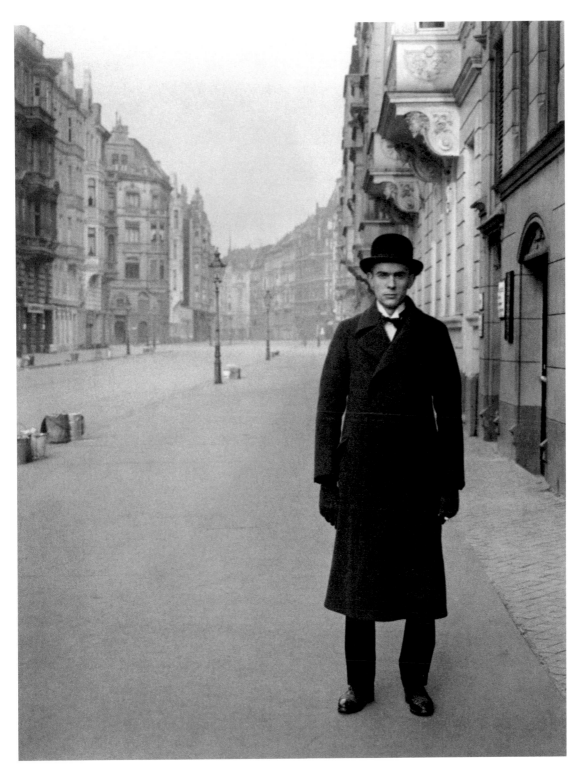

65 Painter [Anton Räderscheidt], 1926

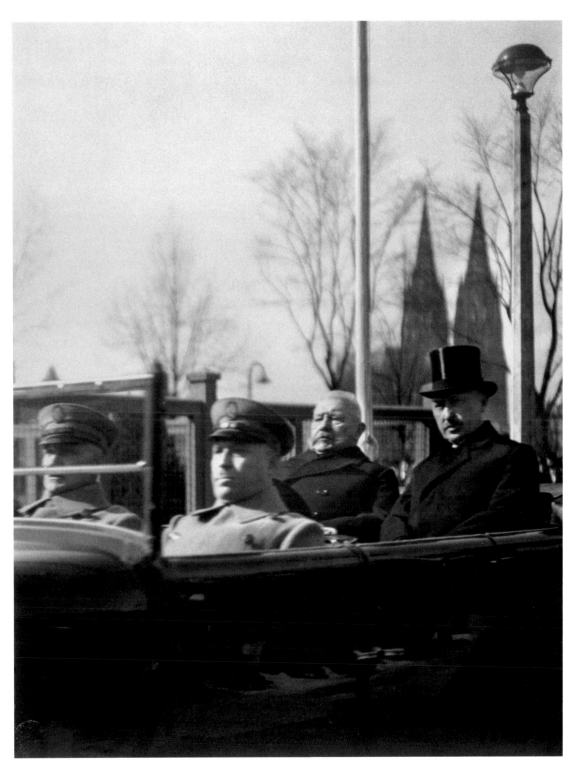

66 President Paul von Hindenburg and Mayor Konrad Adenauer, Cologne, 1926

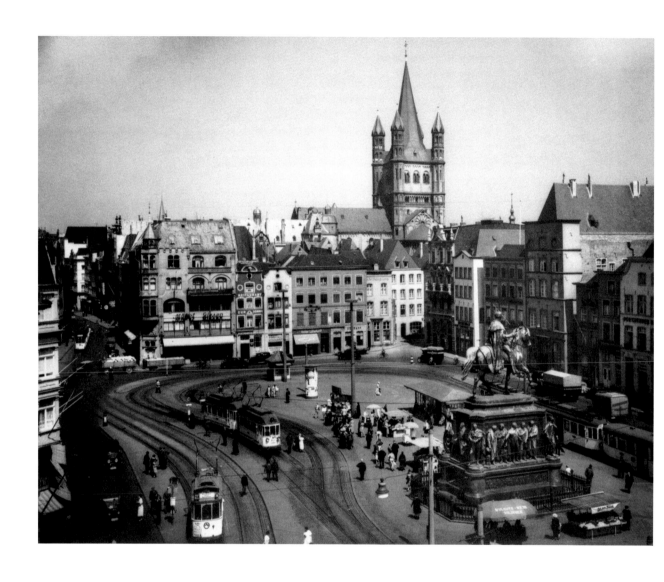

67 The Heumarkt with the monument to Friedrich Wilhelm, Cologne, 1938

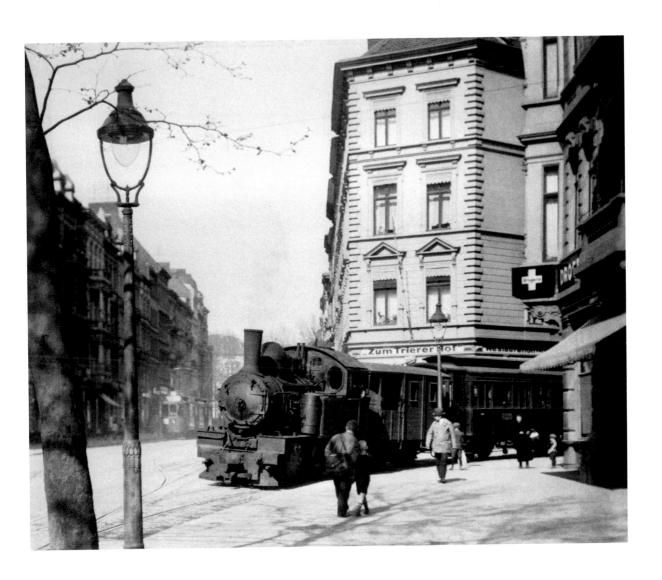

68 The railway "Feuriger Elias", Cologne, c. 1926

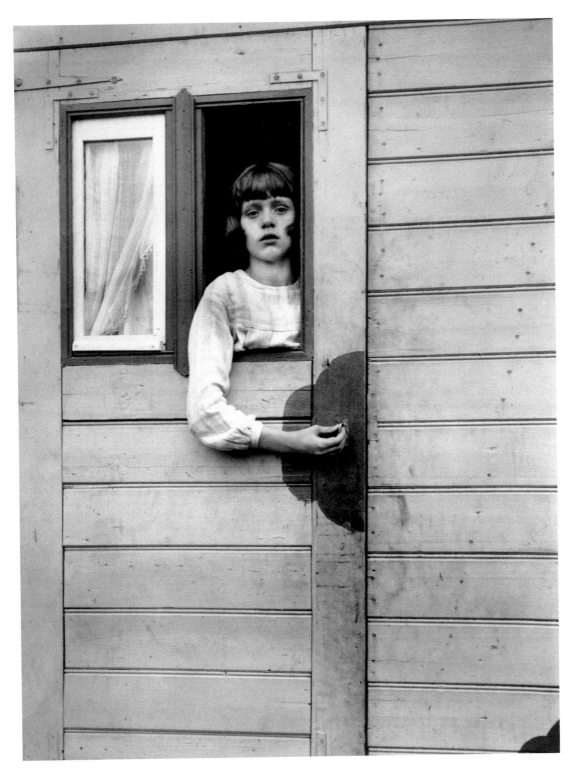

69 Girl in Fairground Caravan, 1926–1932

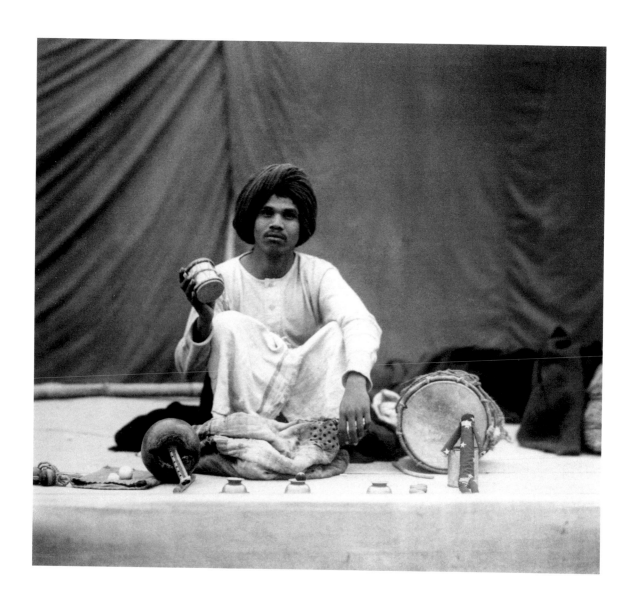

70 Indian Magician, c. 1930

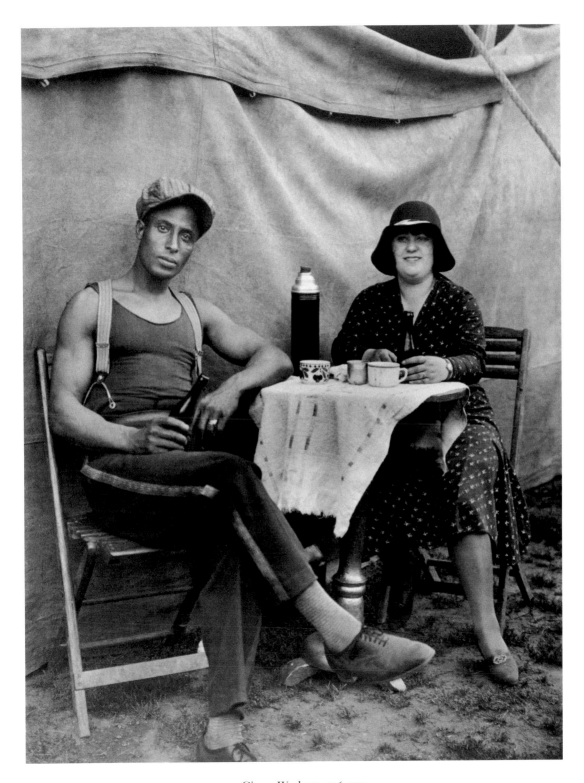

71 Circus Workers, 1926–1932

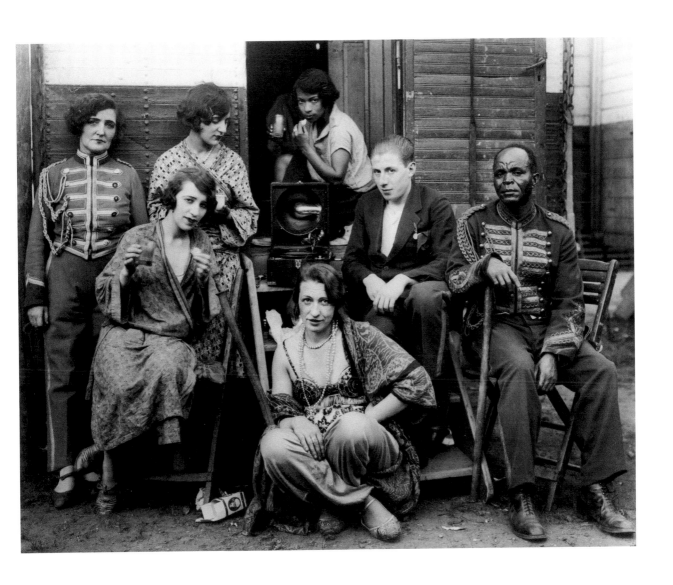

72 Circus Artistes, 1926–1932

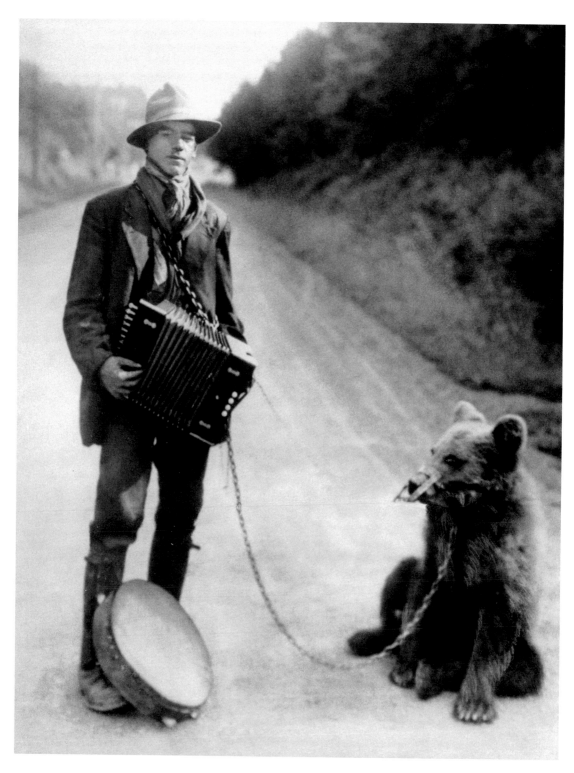

73 Showman with Performing Bear in the Westerwald, c. 1929

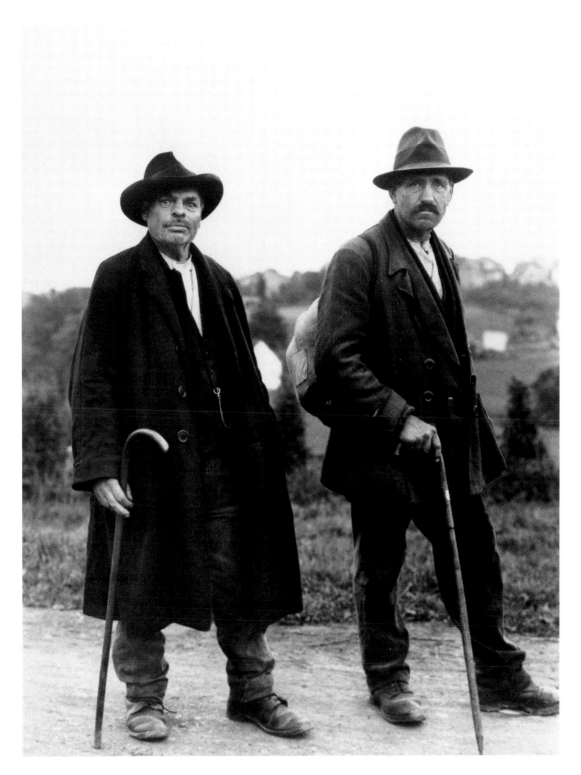

74 Vagrants, 1929

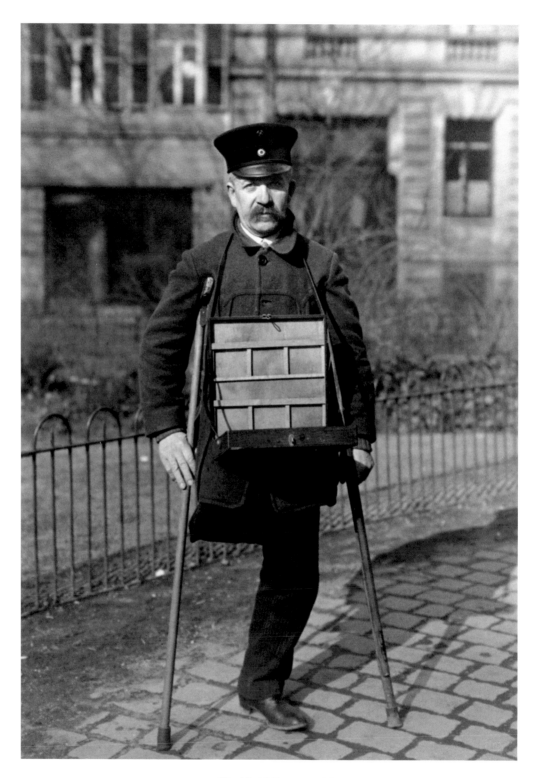

75 Disabled Miner, 1927/28

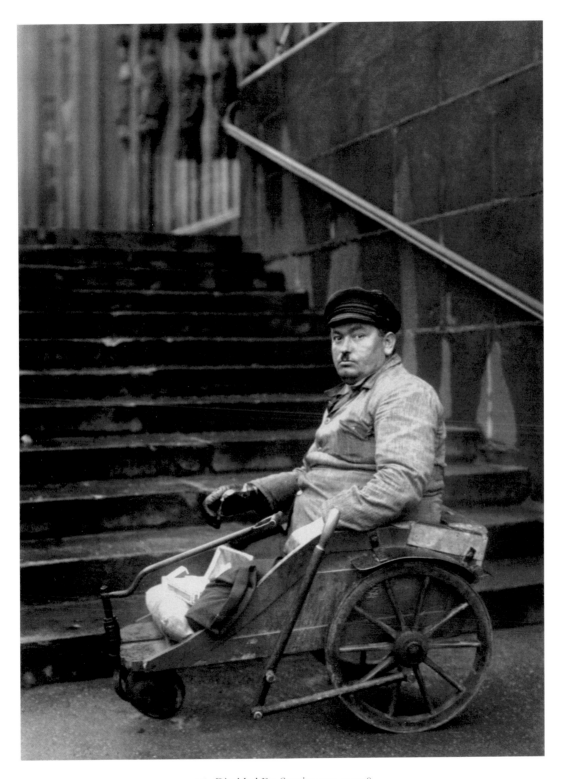

76 Disabled Ex-Serviceman, c. 1928

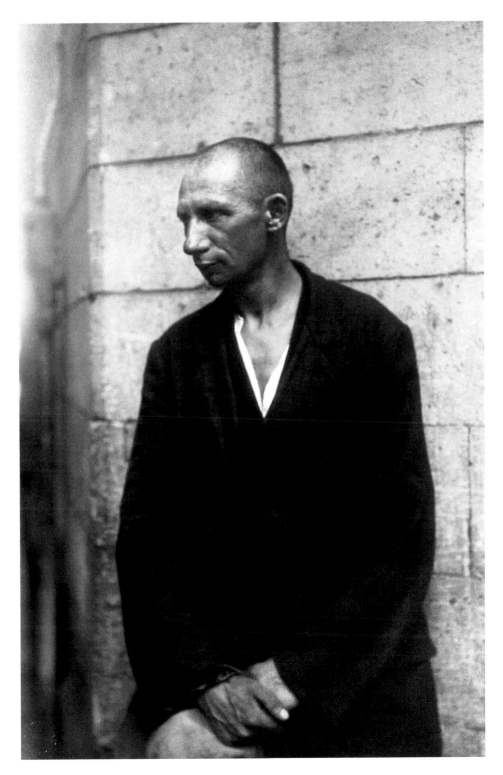

77 Jobless, 1928

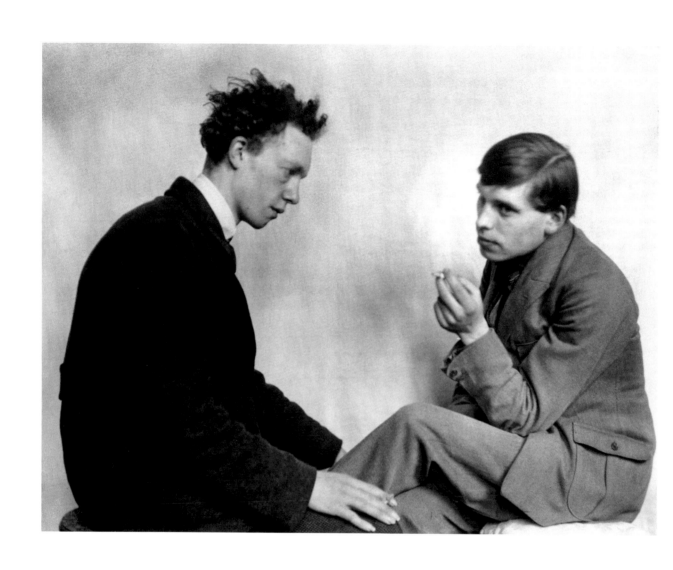

78 Bohemians [Willi Bongard and Gottfried Brockmann], 1922–1925

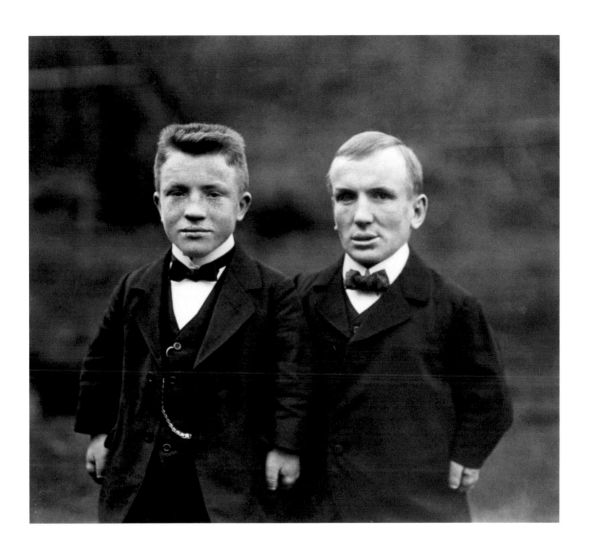

79 Midgets, 1906–1914

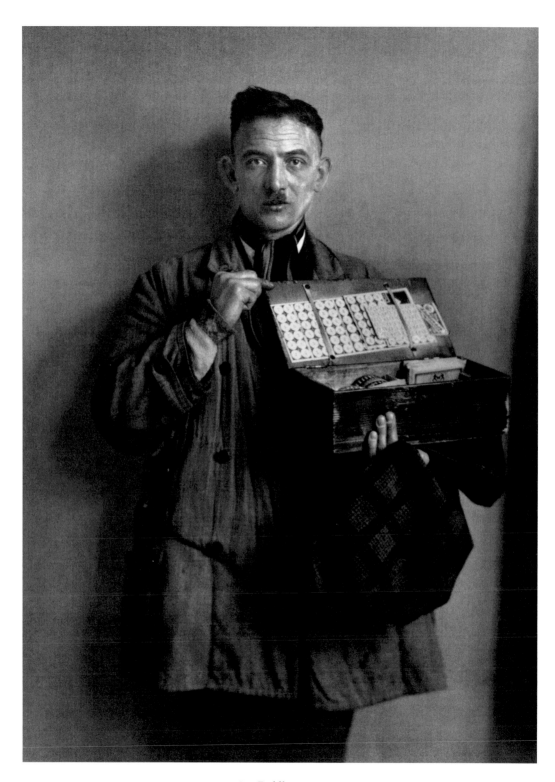

80 Peddler, 1930

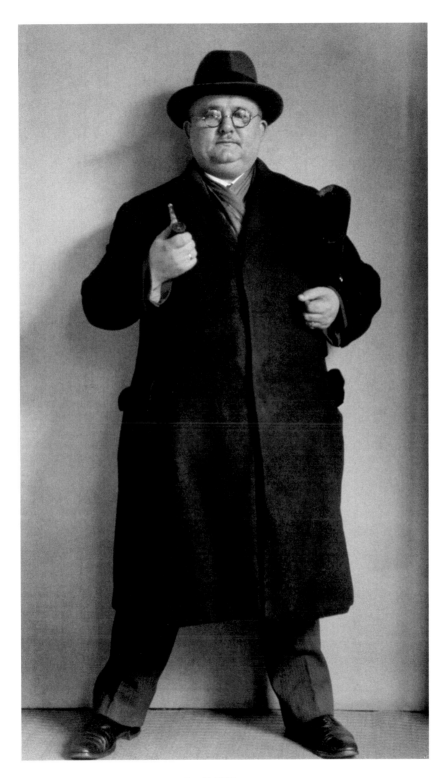

81 Bailiff, c. 1930

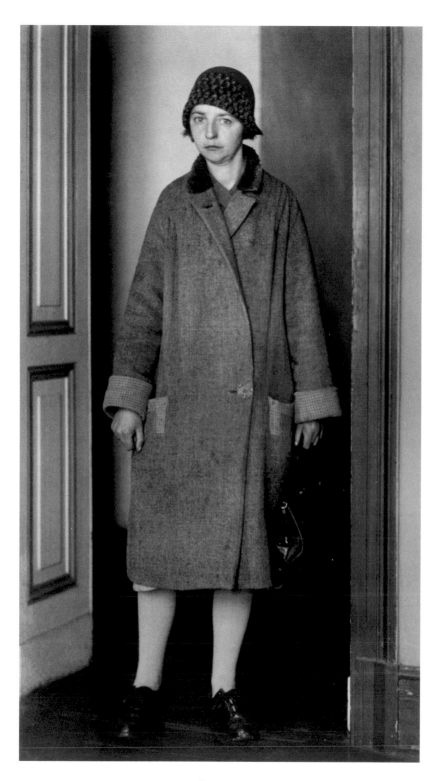

82 Beggar, 1930

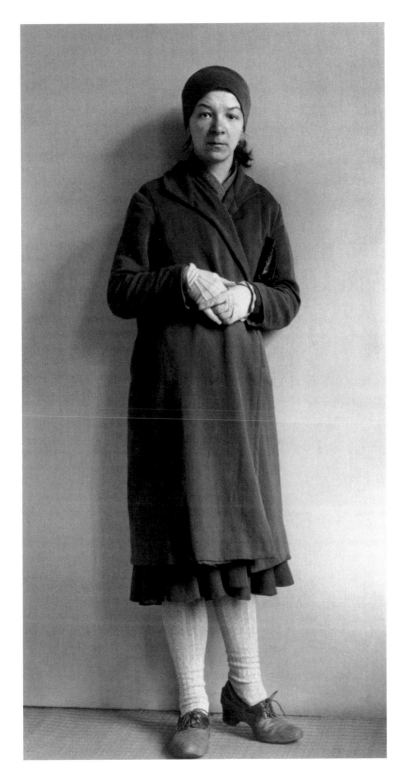

83 Beggar, 1930

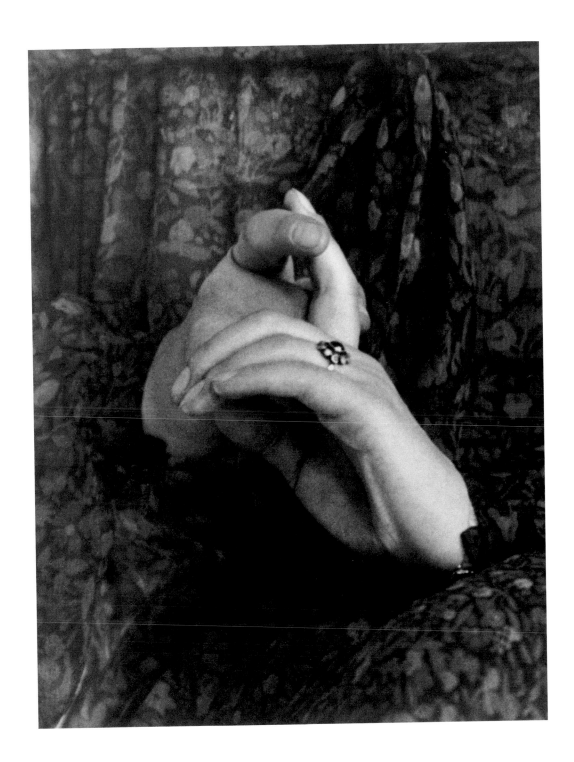

84 Hand Study, 1930

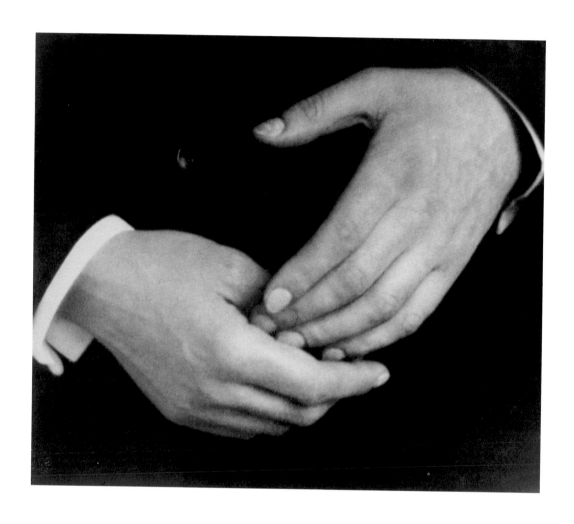

85 Hands of a Young Businessman, 1927

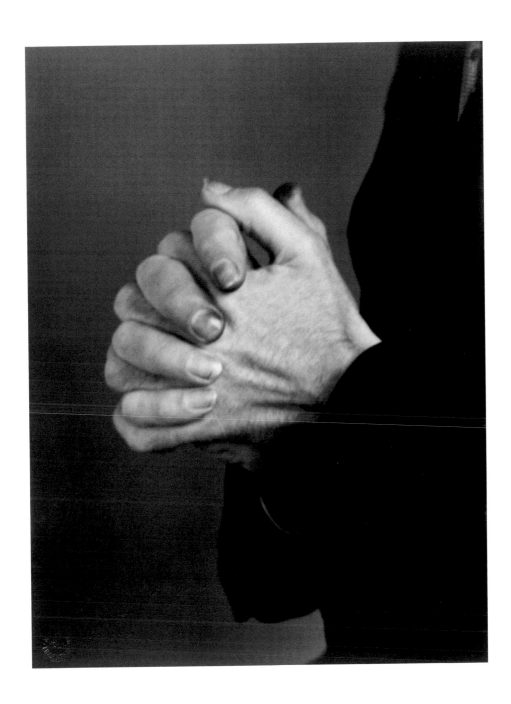

86 Hands of a Touring Player, 1928–1930

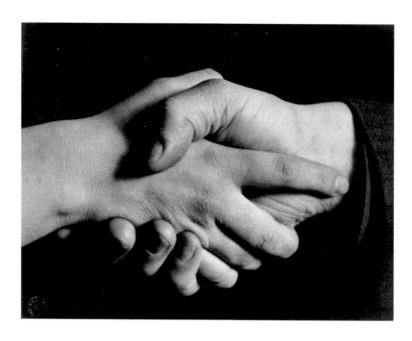

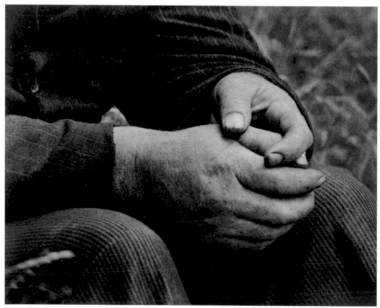

87 Hands, 1935
88 Hands of a Casual Laborer, c. 1930

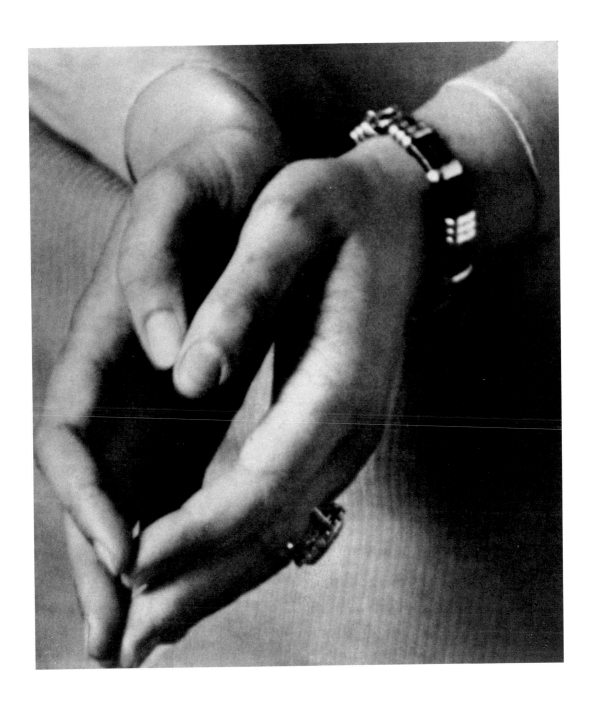

89 Hands of a Sculptress, 1929

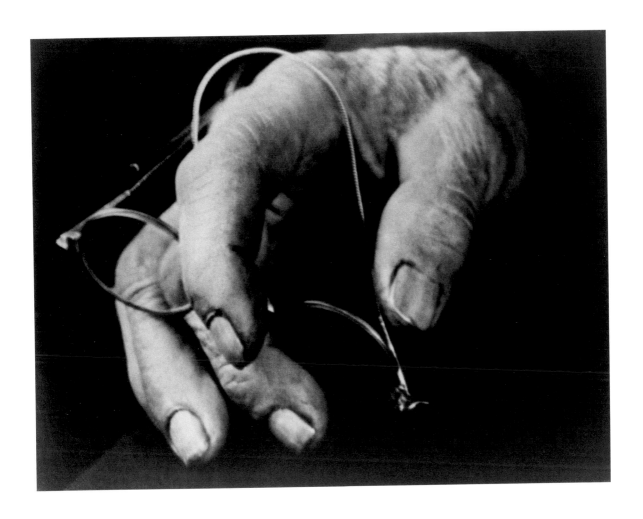

90 Hand of a Farmer, 1911–1914

The essence of all photography is the documentary manner, but we can root this out with our hands. Documentary photography isn't so much about the fulfillment of aesthetic rules pertaining to outer form and composition as it is about the significance of that which is portrayed. Both principles—of aesthetics, and of documentary fidelity—can nevertheless be conjoined when used in a variety of fields.

August Sander, "Review and Vision, Photography at the Turn of the Century", Lecture 3, 29 March 1931

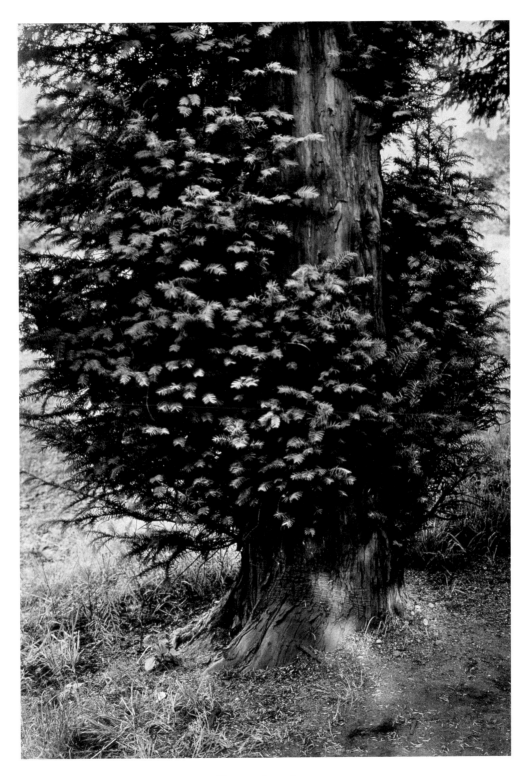

91 Yew tree in spring, 1930s

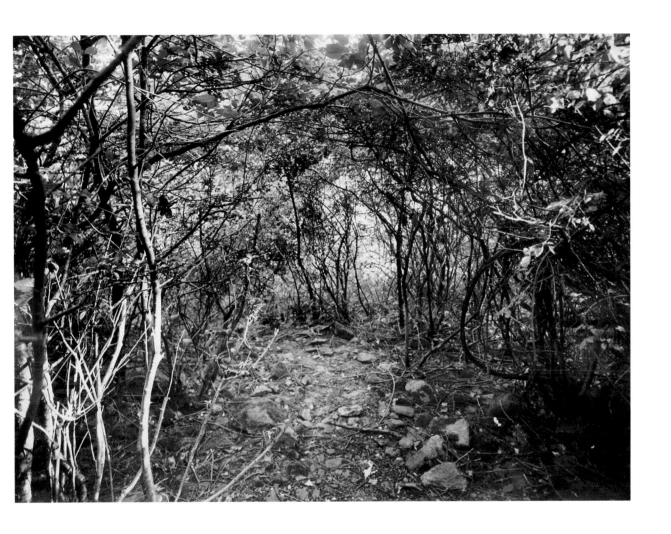

92 Wolkenburg, 1930s

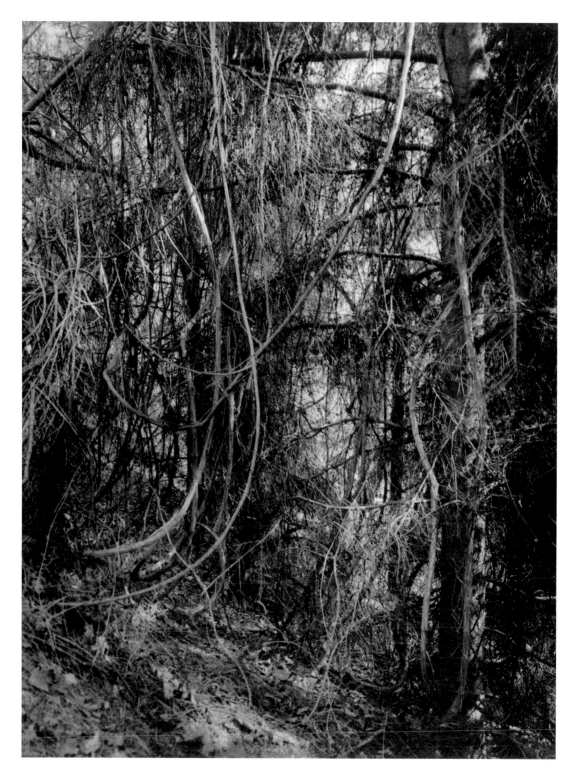

93 The Wolkenburg, lianas and fir trees, early spring, 1938

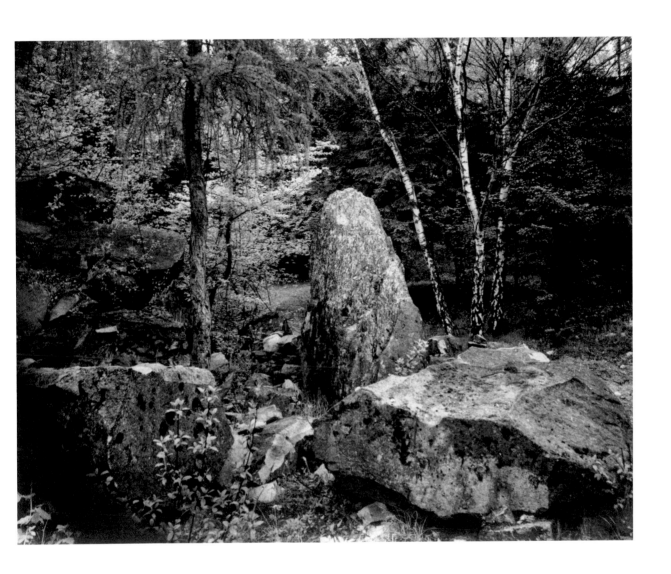

94 The Wolkenburg, 1930s

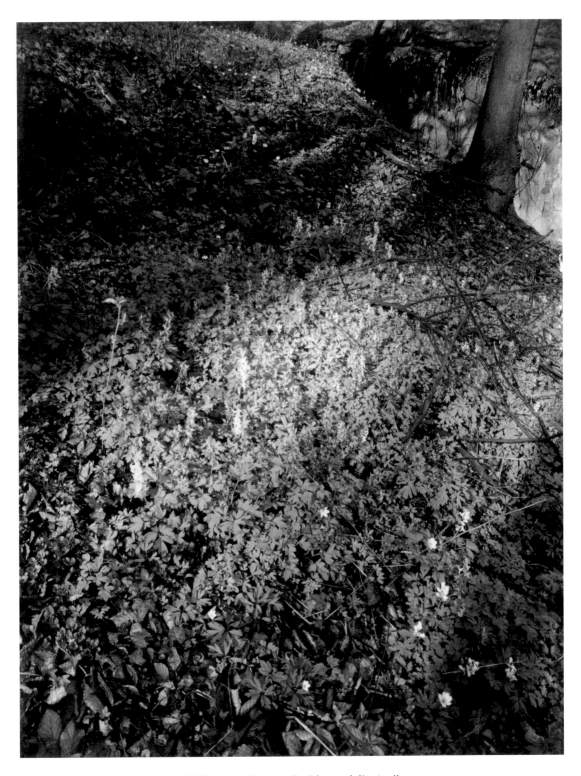

95 Wolkenburg, Forest soil with corydalis, April 1940

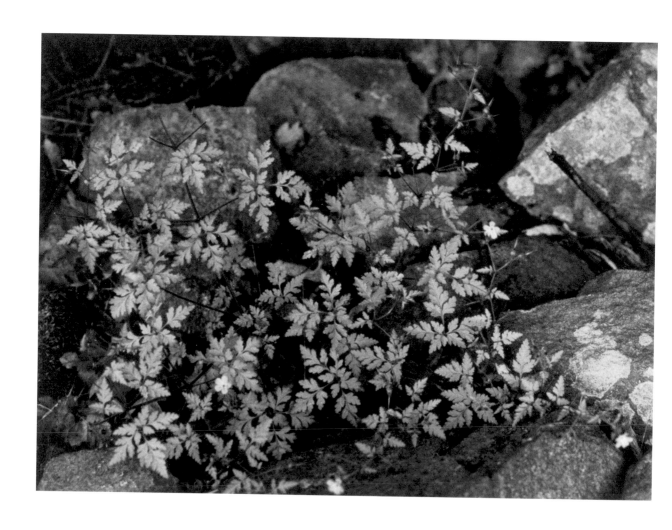

96 Robert geranium, 1930s

97 Plant Study, 1930s

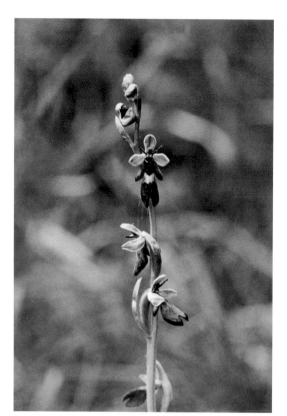

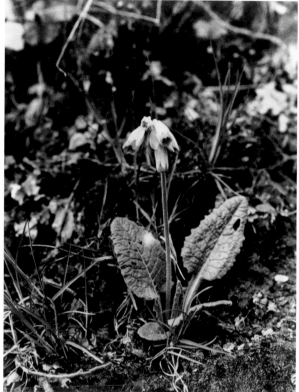

98 Fly orchid, 1930s

99 Cowslip primrose (Primula veris), late 1930s

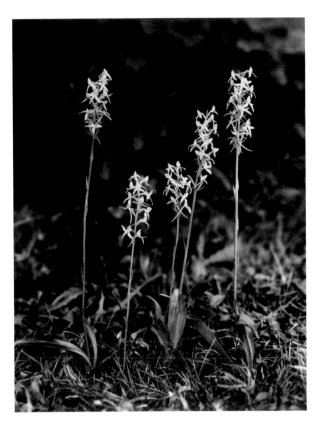

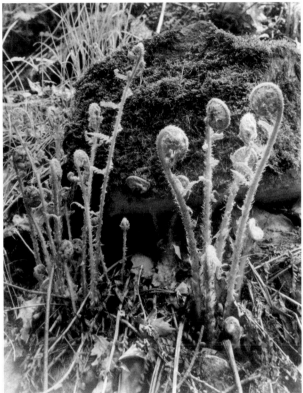

100 Bog orchid (Platanthera bifolia), late 1930s
101 Male woodfern (Dryopteris filix-mas), 1930s

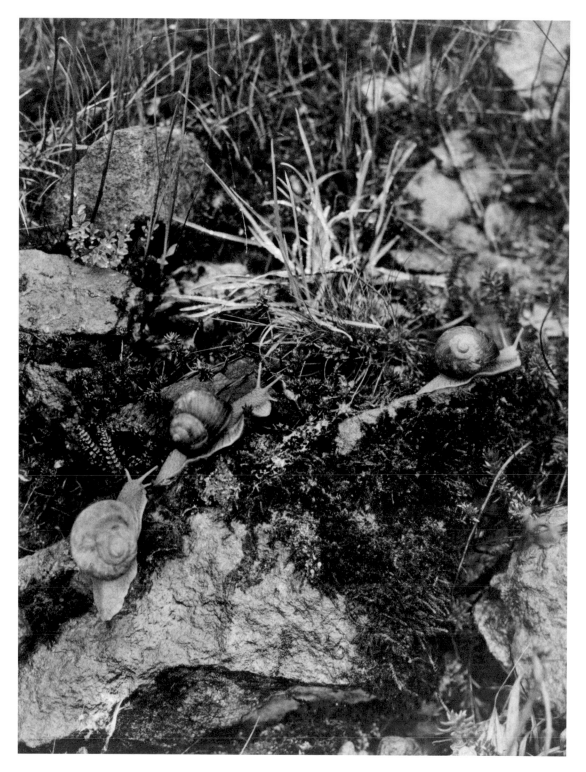

102 Grapevine snails, 1930s

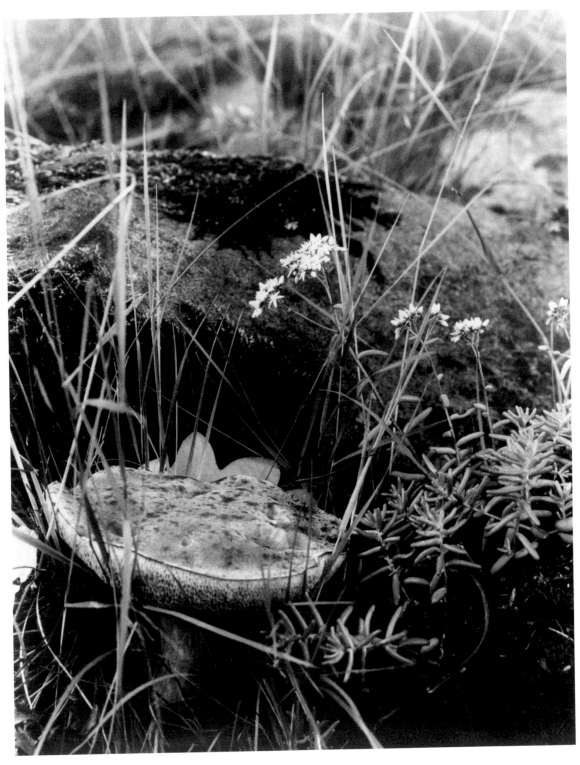

103 Boletus and stonecrop (Boletus edulis, Sedum album), July 1940

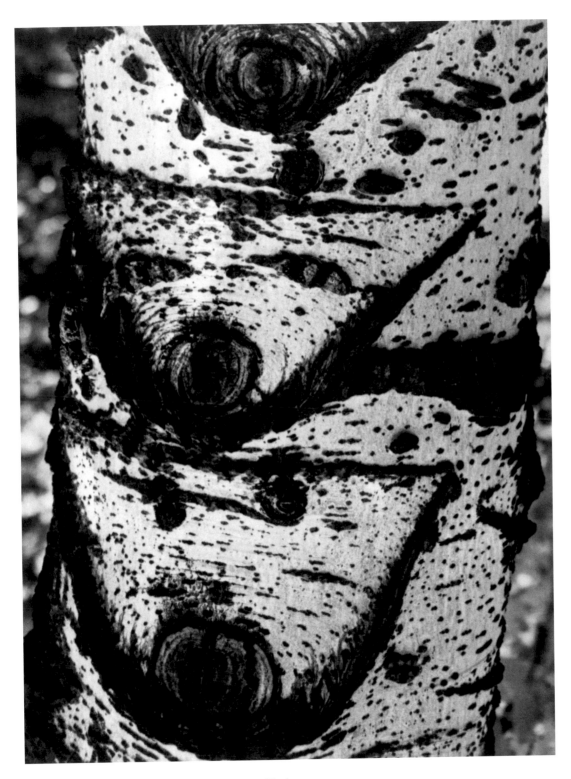

104 Birch tree, 1930s

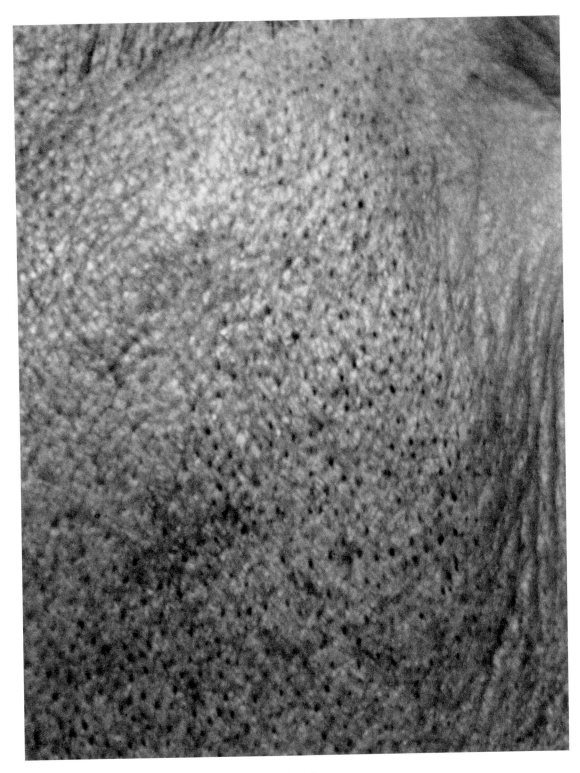

105 Epidermis, c. 1925

List of photographs

If not otherwise stated, all works repro-
duced are Gelatin Silver Prints from
Die Photographische Sammlung/SK
Stiftung Kultur, Cologne. All works are
original vintage prints by August Sander,
except for those where the printing date
is shown in brackets.

1 August Sander in the Siebengebirge,
 c. 1941
 23.0 x 17.3 cm

2 The Siebengebirge: View from the
 Rolandsbogen, 1929/30
 16.5 x 23.8 cm

3 View of the Siebengebirge from the
 Viktoria Mountain near Remagen,
 1930
 17.0 x 23.5 cm

4 The Rhine Valley with Nonnen-
 werth Island, 1930
 17.4 x 23.5 cm

5 View of the Rhine Valley, Königs-
 winter, Godesberg, Bonn and
 Cologne, 1930
 17.0 x 23.5 cm

6 The structure of the Siebengebirge
 mountains, 1930
 16.1 x 23.8 cm

7 Thing site near Niederdollendorf,
 1930
 17.1 x 23.3 cm

8 The Löwenburg Mountain,
 before 1934
 23.3 x 17.2 cm

9 Quarry in the Siebengebirge,
 before 1935
 23.1 x 17.2 cm

10 View of the Siebengebirge from
 Rheinbreitbach, before 1935
 16.6 x 23.7 cm

11 Area around Heisterbach,
 before 1934
 16.8 x 23.8 cm

12 The Drachenfels in the Rhine Valley,
 before 1935
 17.3 x 23.5 cm

13 The Siebengebirge seen from the
 Heights of the Westerwald,
 before 1934
 17.0 x 23.2 cm

14 The Siebengebirge seen from the
 Westerwald, 1930s
 21.8 x 29.0 cm

15 Siebengebirge, 1936
 22.9 x 29.4 cm

16 The Rhine near the Erpeler Ley
 rock, 1930s
 23.5 x 29.3 cm

17 The Hammerstein ruins, 1930s
 23.1 x 29.2 cm

18 Basalt quarry in the Siebengebirge, c.
 1938
 29.1 x 21.3 cm

19 The Rhine loop near Boppard, 1938
 41.0 x 58.0 cm

20 View of Heuzert near Kroppach,
 1930s
 23.5 x 29.3 cm

21 View of the Siebengebirge from
 Uckerath, 1930s
 22.8 x 28.9 cm

22 Borod near Hachenburg, 1930s
 22.9 x 28.5 cm

23 Wiedtal, Almersbach Church, 1930s
 (printed 1998)
 17.3 x 23.4 cm

24 The Rhine near Bad Godesberg,
 1930s
 17.0 x 23.4 cm

25 Stromberg, 1953
 28.6 x 23.2 cm

26 Neandertal Motorway bridge,
 c. 1938
 16.6 x 23.1 cm

27 Lignite area near Euskirchen,
 1928–1938
 16.8 x 23.0 cm

28 Gemünd/Eifel, c. 1930 (printed 1998)
 16.8 x 23.1 cm

August Sander – Biography

1876 August Sander is born on November 17 in Herdorf to August Sander sen., a mining carpenter, who was later disabled, and Justine Sander, née Jung. August Sander junior has six siblings. He attends the local elementary school.

1890–1896 Works on the mining waste tip at Herdorf iron-ore mine. Strikes up an acquaintance with a professional photographer from Siegen, who arouses his interest in photography. With the financial support of his uncle, he buys his first photographic equipment .

1897–1909 Military service and training under Trier-based photographer Georg Jung. He spends years traveling to Berlin, Magdeburg, Halle, Leipzig and Dresden, among others, and works in various photographic studios. Also interested in painting. Works for the *Photographische Kunstanstalt Greif* in Linz on the Danube (Austria), which together with a partner he takes over in 1902, only to later run it on his own. He becomes a member of the Upper Austrian Art Society (approx. 1904-9). In his *Atelier für bildmäßige Photographie* Sander offers "photographic works of every kind". Sander receives numerous prizes for his photographs, which are frequently exhibited. In 1902 he marries Anna Seitenmacher. Birth of their sons Erich (1903) and Gunther (1907).

1910–1920 Relocates to Cologne. Birth of the twins Sigrid and Helmut (1911), but only Sigrid survives. Expands his studio work in Cologne's Lindenthal district at Dürener Strasse 201. Begins photographic work in the Westerwald region, producing images he will later incorporate into his work *Menschen des 20. Jahrhunderts* (People of the 20th Century). Sander is conscripted at the start of World War I and does not return until the end of the war in 1918. Anna Sander runs the business in his absence.

from 1920 Intensive exchange with the *Kölner Progressive* artists group, above all with Franz Wilhelm Seiwert and Heinrich Hoerle. The ideas and concept for his large portrait project *Menschen des 20. Jahrhunderts* mature. First presentation of the project in the Cologne *Kunstverein* (November 1927); that same spring he travels to Sardinia with the author Ludwig Mathar. As a preview to *Menschen des 20. Jahrhunderts* the illustrated publication *Antlitz der Zeit* [Face of Our Time] is published in 1929. Sander holds a series of six lectures on the topic "The Essence and Development of Photography" in the Westdeutscher Rundfunk (1931). Sander's son Erich, a member of the *SAPD* (German Socialist Workers Party), which is banned from 1933, is informed on and condemned to ten years' imprisonment (1934). The National Socialists prevent delivery of *Antlitz der Zeit* and destroy the printing plates. Publishers L. Schwann, Düsseldorf, and L. Holzwarth, Bad Rothenfelde, publish six booklets each portraying a region of Germany (1933–1935). The images they contain by August Sander, but also taken by Erich Sander for the family business, address various topics focusing on landscape and architecture. Sander also produces botanic studies and detailed studies, for example of hands. Sander realizes numerous commissions in the areas of industry and advertising. The ongoing war obliges the Sanders to leave Cologne. They begin the move to their new home in the Westerwald village, Kuchhausen, in 1942. The Cologne studio is destroyed by bombing. Sander is able to salvage the most important sections of the archive and transport them to his new home (1942-3).

1944–1946 Sander's son Erich dies in the Siegburg prison (1944) from an untreated and acute ruptured appendix. 25,000 to 30,000 negatives, which were stored in the cellar of their Cologne flat are destroyed in a fire (January 1946). Though the conditions are difficult he continues to devote himself to his many photographic projects. August Sander keeps up the contacts from his time in Cologne.

1951–1962 At the initiative of photography publisher and sponsor L. Fritz Gruber, exhibition featuring August Sander's works at the second *photokina* (1951) and visit by Edward Steichen, Director of the photography department of the Museum of Modern Art, New York (1952). Sale of the portfolio project *Köln, wie es war* (Cologne as it once was) to the City of Cologne (1953). Participates in the traveling exhibition curated by Steichen, *The Family of Man* (1955). Given the freedom of his native village Herdorf (1958). Special issue of the Swiss monthly magazine *du* (1959). Order of the Federal Republic of Germany, first class and awarded the prize of the *German Society for Photography* (1960/61). Publication of the book *Deutschenspiegel* with an introduction by Heinrich Lützeler (1962).

1957 Anna Sander dies on 27 May in Kuchhausen.

1964 August Sander dies on 20 April in Cologne.

Selected Bibliography

August Sander: *Antlitz der Zeit. Sechzig Aufnahmen deutscher Menschen des 20. Jahrhunderts*, Introduction by Alfred Döblin, Munich: Kurt Wolff/Transmare Verlag, 1929 (further editions Munich: Schirmer/Mosel, 1976, 1990, 2003, French Edition: Munich: Schirmer/Mosel, 1990, English Edition: Munich: Schirmer/Mosel, 1994, 2003)

Bergisches Land, Text and Photographs by August Sander, Ed. Joh. Gg. Holzwarth, Düsseldorf: L. Schwann Verlag, undated [1933] (*Deutsche Lande – Deutsche Menschen*)

Die Eifel. Text and Photographs by August Sander, Ed. Joh. Gg. Holzwarth, Düsseldorf: L. Schwann Verlag, undated [1933] (*Deutsche Lande – Deutsche Menschen*)

Die Mosel. Text and Photographs by August Sander, Bad Rothenfelde: L. Holzwarth Verlag, 1934 (*Deutsches Land/Deutsches Volk*, vol. 2)

Die Saar, Photographs by August Sander, Text by Josef Witsch, Bad Rothenfelde: L. Holzwarth Verlag, 1934 (*Deutsches Land/Deutsches Volk*, vol. 4)

Das Siebengebirge, Text and Photographs by August Sander, Bad Rothenfelde: L. Holzwarth Verlag, 1934 (*Deutsches Land/Deutsches Volk*, vol. 3)

Am Niederrhein, Photographs and Preface by August Sander, Introduction by Ludwig Mathar, Bad Rothenfelde: L. Holzwarth Verlag, 1935 (*Deutsches Land/Deutsches Volk*, vol. 1) „August Sander photographiert: Deutsche Menschen", in: *du* Kulturelle Monatsschrift, Texts by Alfred Döblin, Manuel Gasser and Golo Mann, 19. Jg., Nr. 225, Zürich, 11/1959

August Sander: *Deutschenspiegel. Menschen des 20. Jahrhunderts*, Introduction by Heinrich Lützeler, Gütersloh: Sigbert Mohn Verlag, 1962

August Sander. Rheinlandschaften. Photographien 1929–1946, Text by Wolfgang Kemp, Munich: Schirmer/Mosel, 1974, 1981

August Sander. Menschen ohne Maske, with a biographical text by Gunther Sander and a preface by Golo Mann, Luzern/Frankfurt, Main: C. J. Bucher-Verlag, 1971 (Special Edition, Munich: Schirmer/Mosel, 1976)

August Sander. Menschen des 20. Jahrhunderts. Portraitphotographien 1892–1952, Ed. Gunther Sander, Text by Ulrich Keller, Munich: Schirmer/Mosel, 1980 (Editions in English, Italian, Japanese)

August Sander: Photographs of an Epoch 1904–1959, Preface by Beaumont Newhall, Text by Robert Kramer, New York: Aperture, 1980

August Sander: „In der Photographie gibt es keine ungeklärten Schatten!", a publication for the exhibition of the same name, curated by Gerd Sander, Venues: State Puschkin-Museum for the Arts, Moscow, Watari-um, Museum of Contemporary Art, Tokyo, Kunstmuseum Bonn, Centre National de la Photographie, Paris, Palais des Beaux-Arts, Brüssel, Stedelijk Museum, Amsterdam, Museo di Storia della Fotografia Fratelli Alinari, Florenz, National Portrait Gallery, London, Preface by Susanne Lange, Texts by Gerd Sander, Christoph Schreier, Berlin: Ars Nicolai, 1994

August Sander. Köln wie es war, Ed. Kölnisches Stadtmuseum and August Sander Archiv/Kulturstiftung Stadtsparkasse Köln, Texts by Susanne Lange and Christoph Kim, Amsterdam 1995

August Sander. Introduction by Susanne Lange, Ed. Centre National de la Photographie, Paris, Photo Poche 64, Arles: Actes Sud, 1995

August Sander. Landschaften, Text by Olivier Lugon, Ed. Die Photographische Sammlung/SK Stiftung Kultur, Köln, Munich/Paris/London: Schirmer/Mosel, 1999

August Sander 1876–1964. Ed. Manfred Heiting, Text by Susanne Lange, Cologne, Madrid, London, New York, Paris, Tokyo: Taschen, 1999

Zeitgenossen. August Sander und die Kunstszene der 20er Jahre im Rheinland, Ed. Die Photographische Sammlung/SK Stiftung Kultur, Cologne, Texts by Birgit Bernard, Gertrude Cepl-Kaufmann, Anne Ganteführer-Trier, Wolfram Hagspiel, Klaus Wolfgang Niemöller, Louis Peters, Maria Porrmann, Gerd Sander, Eduard Trier and Arta Valstar-Verhoff, Prefaces by Susanne Lange and Hans-Werner Schmidt, Göttingen: Steidl, 2000

August Sander. Menschen des 20. Jahrhunderts, Study volume, Ed. Die Photographische Sammlung/SK Stiftung Kultur, Köln, a publication accompanying the seven-volume revised version of August Sander's *People of the 20th Century*, Munich: Schirmer/Mosel, 2001 (French edition by Éditions de La Martinière, 2002)

August Sander: Menschen des 20. Jahrhunderts: Ein Kulturwerk in Lichtbildern eingeteilt in sieben Gruppen, revised and newly compiled by Susanne Lange, Gabriele Conrath-Scholl, Gerd Sander, 7 Volumes, Ed. Die Photographische Sammlung/SK Stiftung Kultur, Munich: Schirmer/Mosel, 2002 (French edition by Éditions de La Martinière, US-Edition by Abrams, New York, 2002)

August Sander. Linzer Jahre, 1901–1909, Ed. Die Photographische Sammlung/SK Stiftung Kultur, Cologne, and the Landesgalerie Linz am Oberösterreichischen Landesmuseum, Texts by Gabriele Conrath-Scholl, Martin Hochleitner and Susanne Lange, Munich: Schirmer/Mosel, 2005

Sources of the quotations by August Sander

p. 6: August Sander, "Mein Bekenntnis zur Photographie," [My Confession of Faith in Photography] November 1927, Document REWE-Library in Die Photographische Sammlung/SK Stiftung Kultur – August Sander Archive, Cologne.

Alongside photograph 1: August Sander, "Chronik zur Mappe 3 *Herdorf/Siegerland*" [Chronicle of Portfolio 3, *Herdorf/Siegerland*]. undated [1950s], Document REWE-Library in Die Photographische Sammlung/SK Stiftung Kultur – August Sander Archive, Cologne.

Alongside photographs 2 and 3: [...]"start of a new major project" […], August Sander, Letter to the editor *Velhagen & Klasings Monatshefte*, 30 January 1931, Document REWE-Library in Die Photographische Sammlung/SK Stiftung Kultur – August Sander Archive, Cologne.

Alongside photographs 14 and 29: August Sander, "Die Photographie als Weltsprache" [Photography as a Universal Language], Lecture 5, 12 April 1931, p. 8, Document REWE-Library in Die Photographische Sammlung/SK Stiftung Kultur – August Sander Archive, Cologne.

Alongside photograph 91: August Sander, "Rückblick und Ausblick. Die Photographie um die Jahrhundertwende." [Review and Vision, Photography at the Turn of the Century.] Lecture 3, pp. 7-8, 29 March 1931. Document REWE-Library in Die Photographische Sammlung/SK Stiftung Kultur, Cologne.

Translation from the German by Daniel Mufson

ISBN 978-3-8296-0443-7

A Schirmer/Mosel Production
www.schirmer-mosel.com